REG. U.S. PAT. OFF.

# OF TIME & PLACE

**WALKER EVANS** A N D **WILLIAM CHRISTENBERRY**

# OF TIME

## WALKER EVANS AND WILLIAM CHRISTENBERRY

# & PLACE

**THOMAS W. SOUTHALL**

With excerpts by James Agee
and stories by William Christenberry

UNTITLED 51
THE FRIENDS OF PHOTOGRAPHY, SAN FRANCISCO, AND
THE AMON CARTER MUSEUM, FORT WORTH,
IN ASSOCIATION WITH THE UNIVERSITY OF NEW MEXICO PRESS,
ALBUQUERQUE

Published in conjunction with an exhibition organized by the
Amon Carter Museum.

Amon Carter Museum, Fort Worth, Texas
April 27 - June 24, 1990

Wichita Art Museum, Wichita, Kansas
December 1, 1990 - January 20, 1991

Portland Museum of Art, Portland, Maine
February 17 - April 15, 1991

The Friends of Photography, Ansel Adams Center,
San Francisco, California
July 3 - September 9, 1991

ISSN 0163-7916; ISBN 0-933286-56-2 (paper); 0-933286-57-0 (cloth)
Library of Congress Catalogue No. 90-80082

## CREDITS

Permission to reproduce the photographs and other items
included in this book has been granted by the following individuals
and institutions and is gratefully acknowledged:
Amon Carter Museum Collection: p. 33.  Estate of Walker Evans:
p. 57, 58.  Lee Friedlander: p. 18.  Hallmark Fine Art Collection,
Hallmark Cards, Inc., Kansas City: p. 27 (bottom).  Photography
Collection, Harry Ransom Humanities Research Center, University
of Texas, Austin: pp. 35, 37-39, 41, 43-45, 47-49, 51, 53, 55.  Library of
Congress, Washington, D.C.: pp. 22, 24, 28 (top).  The Menil
Collection, Houston: p. 27 (top).  Myra Morgan Collection: p. 10.
William Christenberry: pp. 9, 10, 13, 14, 17, 20, 28 (bottom), 30, 56, 59,
61, 63-67, 69-71, 73-75, 77, 79, 80, 83-87.

## UNTITLED 51

This is the fifty-first in a series of publications on serious photo-
graphy by The Friends of Photography.  Some previous issues are
still available.  For a list of these, write to Publication Sales, The
Friends of Photography, Ansel Adams Center, 250 Fourth Street,
San Francisco, California 94103.

Printed in Korea through Overseas Printing Corporation.

# ACKNOWLEDGEMENTS

It is not often enough that two organizations as different as the Amon Carter Museum and The Friends of Photography are able to collaborate on a project. Although different in function, each is deeply committed to advancing the understanding of creative photography. The Walker Evans/William Christenberry exhibition and book provided the perfect framework for a joint undertaking. We hope the success of this project will stimulate future collaborations.

This project was conceived by Thomas Southall, curator of photographs at the Amon Carter Museum. His sympathetic interpretations and careful research have given us new appreciation for the work of both artists.

William Christenberry's great contribution is evident throughout every aspect of this publication and the exhibition that it accompanies. Working closely with author Thomas Southall, he generously shared his own artwork and provided invaluable insights into the culture of his native Alabama and the work of Walker Evans. In the initial stages of the project, Gus Kayafas was especially helpful in providing an introduction to William Christenberry and his thoughts on the interrelationships between Evans and Christenberry. William Stott and Peter MacGill also added their perceptions and encouragement.

John Hill, executor of the Walker Evans estate, generously furnished information, shared his understanding of Evans' creative achievements and lent the Evans Polaroids, which are so essential to this presentation. Roy Flukinger and the staff of the Harry Ransom Humanities Research Center, University of Texas, efficiently arranged for reproductions and loans of most of the other Evans photographs included here. Keith Davis, of Hallmark Art Collections, kindly arranged the loan of Christenberry's *Abandoned House* sculpture, even though it required disrupting an installation of the permanent collection.

Houghton Mifflin Company has given permission to quote extensively from Agee's text. Many others have also provided reproduction permissions and assistance, including Lee Friedlander, the Menil Collection, Myra Morgan of the Morgan Gallery and the Prints and Photographs Division of the Library of Congress.

Many staff members of the Amon Carter Museum have made significant contributions to the production of the publication and exhibition. Special thanks are particularly due to editor Nancy Stevens and to members of the photography and registration departments: Barbara McCandless, Jeanie Lively, Anne Adams, Melissa Thompson and Chris Rauhoff. Linda Lorenz, Rynda Lemke, Steven Watson and Gayle Herr-Mendoza provided excellent photographic copy work.

On the staff of The Friends of Photography, director of publications David Featherstone deserves appreciation for championing this collaborative project and for seeing the publication through its editorial and production stages. Volunteers Mark Kielar and Carol Sheinkopf provided valuable editorial assistance. Thanks also go to Michael Mabry and Margie Chu, of Michael Mabry Design, San Francisco, for their creative design for the book.

Ronald Sterling Egherman
Executive Director
The Friends of Photography

Jan Keene Muhlert
Director
Amon Carter Museum

# OF TIME AND PLACE

Thomas W. Southall

ALL OVER ALABAMA, THE LAMPS ARE OUT. EVERY LEAF
DRENCHES THE TOUCH; THE SPIDER'S NET IS HEAVY. THE
ROADS LIE THERE, WITH NOTHING TO USE THEM. THE FIELDS
LIE THERE, WITH NOTHING AT WORK IN THEM, NEITHER MAN
NOR BEAST. THE PLOW HANDLES ARE WET, AND THE RAILS
AND THE FROGPLATES AND THE WEEDS BETWEEN THE TIES:
AND NOT EVEN THE HURRYINGS AND HOARSE SORROWS OF A
DISTANT TRAIN, ON OTHER ROADS, IS HEARD.

—JAMES AGEE, LET US NOW PRAISE FAMOUS MEN

Stewart, Alabama, has never been much more than a few quiet cotton farms and some buildings at a bend in the road. It is not even mentioned in the W.P.A.'s 1941 *Alabama: A Guide to the Deep South*, although nearby Akron, with a population of 504, is listed. When Walker Evans set up his camera in Stewart's unpaved street in the summer of 1936, he did not have to worry about traffic. The view he made, looking across the facades of a couple of modest storefronts toward a cotton warehouse in the distance, shows no activity, but that seems right for a hot summer afternoon in the midst of the Great Depression. Despite its quiet and apparent insignificance, however, the scene Evans photographed was to become important, recorded on film not only as a particular place at a particular time but as an economic and social structure that endured in the South for generations. Evans had come to Hale County in west-central Alabama to work with writer James Agee on an article about sharecroppers for *Fortune* magazine. Their collaboration was to produce one of the classic books on the American South—*Let Us Now Praise Famous Men*—and would shape the art of an Alabama native of a later generation, William Christenberry.

Agee and Evans had traveled around the South for several weeks before they finally ended up in Hale County, in the heart of Alabama's Black Belt region of rich cotton land. The county was an impoverished and primitive area, where the sharecropper system of indentured servitude kept a large population of both blacks and whites in a state of perpetual subsistence and the only paved roads were in the county seat of Greensboro.

One day, while Evans and Agee were still trying to find the right angle for their story, Evans struck up a conversation with a sharecropper who was at the Hale County Court House looking for relief work or government support.[1] Frank Tingle introduced the young reporters to his fellow share-croppers, Bud Fields and Floyd Burroughs. The two well-dressed northerners looked like government agents who might be able to help the farmers, and the sharecroppers invited them back to see their homes and meet their families on Mills Hill, north of Stewart. Agee and Evans soon realized that they had found just the opportunity they were looking for, and these three families—renamed as the Rickets (Tingle), Woods (Fields) and Gudger (Burroughs) families in Agee's text—became the focal point of their work for the next few weeks. Agee virtually moved in with the Burroughses, while Evans mainly stayed at a hotel in town, probably out of reluctance to invade their privacy so forcefully.[2]

In the three weeks they spent working with these families, Evans made more than eighty eight-by-ten-inch negatives of family members, their homes and nearby landmarks like the cotton warehouse in Stewart, where the sharecropper families could sell their cotton and buy their seed. The *Fortune* article was never published—the editors found Agee's text too long and subjective—but eventually an expanded text and Evans' photographs appeared as *Let Us Now Praise Famous Men*, the classic study of the southern sharecropper system and a masterpiece of American literature. When the book appeared in 1941, Evans' thirty-one photographs appeared at the front as an independent portfolio, entirely without captions or text, identified simply as Book One. With uncompromising directness and clarity, his photographs record the worn and worried expressions on the faces of these sharecroppers and their children, the sparse furnishings of their homes and the buildings and landscape of the surrounding communities that constituted their world. In dramatic contrast to the dry, seemingly objective detachment of Evans' photographs, Agee's dense and effusive text, identified as Book Two, creates a complex montage of different narrative forms, shifting back and forth from self-confessional first-person narration to ruminations on art and the meaning and ethics of documentary journalism; to lists and obsessively detailed inventories and descriptions of the families' homes, clothing, possessions and lives; to quoted dialogue; to verbatim excerpts from newspapers, entries in the family Bible and even lessons from discarded geography schoolbooks. Agee's multiple narratives and viewpoints find meaning in

even the most seemingly insignificant detail and demonstrate that no single literary form could do justice to the underlying complexity of the sharecroppers' lives.

In November of 1936, the same year Evans and Agee were researching their article, William Christenberry was born in Tuscaloosa, just north of Hale County.[3] His father's parents lived on a farm in Stewart; his mother's a few miles away in Akron. Christenberry got to know Hale County in his youth while visiting his grandparents and spending most of the summer on their farms. He would frequently stop in Stewart to buy a soda or groceries at the store shown in Evans' photograph or to pick up mail at the post office in the foreground. He also remembers details Evans didn't capture, like the little spring, across the street from the store, that provided thirst-quenching cool water on hot summer days.

Christenberry was not aware that these buildings might carry any special significance to others until 1960, when he came across the newly published second edition of *Let Us Now Praise Famous Men* in a Birmingham bookstore. At the time, he had completed his undergraduate and master's degrees in painting at the University of Alabama and, at age twenty-four, was continuing there as an instructor of drawing and design.

Christenberry was captivated by Evans' photographs, which clearly defined the terrain and encapsulated the conditions and texture of the Alabama he knew, but Agee's text was even more meaningful to him. He later recalled, "What Agee was writing about and the way he was doing it was precisely what I wanted to do in painting, but did not know how. I am still not certain to this day that it can be done."[4] He was particularly moved by one of Agee's most eloquent passages, one that explains the impossibility of communicating in mere words the complexity and value of the sharecroppers' seemingly uncomplicated existence:

IF I COULD DO IT, I'D DO NO WRITING AT ALL HERE. IT WOULD BE PHOTOGRAPHS; THE REST WOULD BE FRAGMENTS OF CLOTH, BITS OF COTTON, LUMPS OF EARTH, RECORDS OF SPEECH, PIECES OF WOOD AND IRON, PHIALS OF ODORS, PLATES OF FOOD AND OF EXCREMENT....

A PIECE OF THE BODY TORN OUT BY THE ROOTS MIGHT BE MORE TO THE POINT.

AS IT IS, THOUGH, I'LL DO WHAT LITTLE I CAN IN WRITING. ONLY IT WILL BE VERY LITTLE. I'M NOT CAPABLE OF IT; AND IF I WERE, YOU WOULD NOT GO NEAR IT AT ALL. FOR IF YOU DID, YOU WOULD HARDLY BEAR TO LIVE.[5]

This passage might serve as a credo for the subsequent development of Christenberry's art: in the following decades he has explored Hale County through an intense, multimedia approach incorporating photography, painting and drawing, sculpture and various forms of three-dimensional assemblages. The book inspired him to modify his painting style, which had been largely non-objective in keeping with the then-dominant abstract expressionist aesthetic, and he began to incorporate representational motifs drawn from his Alabama environment. The Tenant House series of paintings he did in the early 1960s, for example, retained this use of bold, expressive brushwork but also celebrated the vernacular architecture of his birthplace. In 1964 he removed a Grapette sign from the Palmist Building and incorporated this artifact of the region into a painting, *Advertisement*. Not long after that, he began collecting Hale County signs and appreciating them on their own as records of the place and the process of change.

In 1958, Christenberry started making snapshots of Hale County subjects he wanted to incorporate into his paintings, using simple Brownie cameras that he and his siblings had received years earlier "from Santa Claus."[6] He did not regard these snapshots as anything more than reference images until 1960 when, with *Let Us Now Praise Famous Men* as a guide, he retraced the steps of his predecessors, often making new photographs in places that Evans and Agee had been. In a Brownie image of the Stewart storefronts and warehouse, Christenberry tried to recreate as closely as possible Evans' viewpoint in the earlier photograph. However, the Hale County subjects meant something different to him as an Alabama native than they had to the northern visitors decades earlier. If Evans and Agee had discovered strength and beauty in the midst of the poverty and deprivation of the Depression, Christenberry found in their work an opening to the past of his youth and to the traditions and culture of his family and the South in general. He found new personal connections to the work of Agee and Evans at every juncture. When he rediscovered the old cotton warehouse in Stewart, it had long since been abandoned. Written in the seed-sales record on

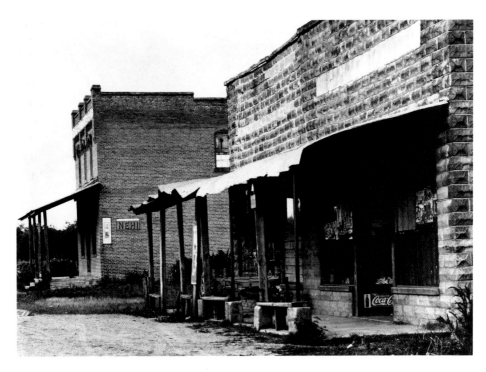

Walker Evans
COTTON WAREHOUSE AND GROCERY STOREFRONTS
STEWART, ALABAMA, 1936

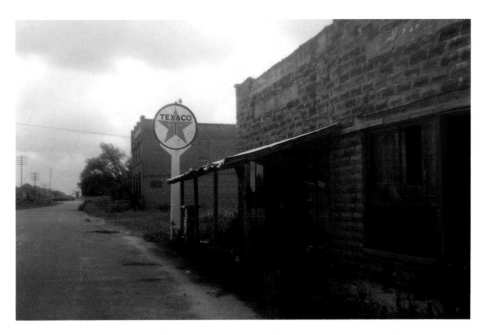

William Christenberry
COTTON WAREHOUSE AND STOREFRONT
STEWART, 1960

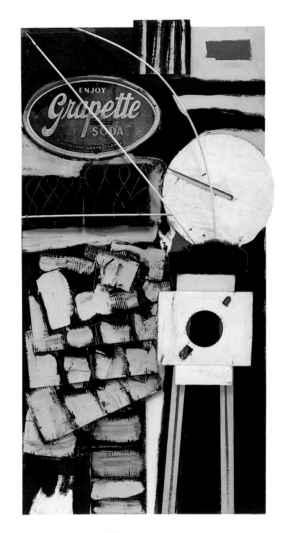

William Christenberry
ADVERTISEMENT, 1964
Mixed media
Photograph by E. G. Schempf

the interior wall he found the name of his grandfather Christenberry; not far away was the name of Frank Tingle, one of the tenant farmers.

The buildings in Stewart continued to draw Christenberry back, and as they did they took him beyond Evans' and Agee's study into new discoveries of change over time. He made Brownie photos in 1962 and 1964 of the facade of the still-operating general store he used to frequent. In 1966 he removed the Nehi sign from the side of the decaying warehouse. Not long after that it was torn down, and Christenberry heard it was purchased by a Tuscaloosa doctor who used the old brick for his new residence. When he photographed the storefront again in 1983, it too had been abandoned; the tall blades of green grass growing across the entrance contrasted with the fading red paint that had been so vibrant in his first image. By 1988, when he photographed the entryway yet again, the doors hung open and, in the absence of a roof, light shone mysteriously from the dark structure's interior. The old signs for Grapette and Coke had been superseded by handmade graffiti scrawls, marking the building's transformation into a hangout for teenage lovers.

It is now more than five decades since Walker Evans and James Agee explored Hale County, and Christenberry's first photographs of the region, made in the late 1950s and early 1960s, are almost thirty years old, more remote from us today than Evans' work was when Christenberry first encountered it. In this half-century, Hale County has served the creative work of the three artists much as William Faulkner's famed Yoknapatawpha County, Mississippi, served his fiction. Faulkner's stories and novels, set there over a period of more than a century and encompassing numerous generations, social classes and races, explore the human condition in the unique southern environment, with its powerful emphasis on place and tradition. Faulkner said in a famous 1956 interview:

I DISCOVERED THAT MY OWN LITTLE POSTAGE STAMP OF NATIVE SOIL WAS WORTH WRITING ABOUT AND THAT I WOULD NEVER LIVE LONG ENOUGH TO EXHAUST IT, AND BY SUBLIMATING THE ACTUAL INTO APOCRYPHAL I WOULD HAVE A COMPLETE LIBERTY TO USE WHATEVER TALENT I MIGHT HAVE TO ITS ABSOLUTE TOP. IT OPENED UP A GOLD MINE OF OTHER PEOPLES, SO I CREATED A COSMOS OF MY OWN. I CAN MOVE THESE PEOPLE AROUND LIKE GOD, NOT ONLY IN SPACE BUT IN TIME TOO....I LIKE TO THINK OF THE WORLD I CREATED AS BEING A KIND OF KEYSTONE IN THE UNIVERSE; THAT, AS SMALL AS THAT KEYSTONE IS, IF IT WERE EVER TAKEN AWAY, THE UNIVERSE ITSELF WOULD COLLAPSE.[7]

Hale County, or more accurately, the small part of it encompassing some farming families and roadside buildings in a few small towns, has similarly served as a cosmos for Evans, Agee and Christenberry to explore their ideas. Like Faulkner, all three have concentrated on the details of a narrowly defined place to search for more universal truths; in choosing what to explore or ignore, each artist has in a sense invented his own version of Hale County. However, the three are dealing with a real place, unlike Faulkner's fictional Yoknapatawpha County; their differing perspectives and media and their varied interpretations remain linked by the reality of Hale County. They have had much less freedom than Faulkner to create characters and to control their cosmos, but this factual foundation has given them all a special intensity as they straddled the line between invention and the documentation of a real place.

Comparing their work gives insight into their different styles and amplifies their shared interests. Each artist created a powerful tension between the realism he sought to convey and the control and subjectivity that he ultimately exerted in constructing his art. The interplay between Evans' portfolio of images and Agee's text in *Let Us Now Praise Famous Men* draws part of its power from the exposed biases of each artist. Likewise the contrast between Evans' cool black and white and Christenberry's lush color images of the same scenes illuminates the distinctive characteristics of each artist's style.

These comparisons do not simply bring together different artists who have some points in common; instead, each artist has approached Hale County with a broad, almost collaborative perspective. Evans' and Agee's work in the Depression was, from its inception, designed to intensify an experience by presenting it in two media at the same time. As Agee wrote, "The photographs are not illustrative. They, and the text, are coequal, mutually independent, and fully collaborative."[8] Their joint endeavor, with its concern about representations of time and place, in turn has inspired Christenberry's continued effort, decades later and over a

long period of time, to amplify his forerunners' creations.

While Christenberry's images could not directly affect the work of the earlier artists, they certainly can and do influence the way we view and interpret Evans' and Agee's art. While *Let Us Now Praise Famous Men* is inexorably tied to our image of rural America during the Depression, Christenberry's evidence of similar subjects and scenes, appearing decades later, frees the earlier work, in the minds of readers and viewers, from the temporal bounds of a specific point in time and confirms its inherent fatalism. Likewise, the book creates resonances in Christenberry's images—even his most recent ones—that link them with that earlier time.

Evans said he wanted to "photograph the present as it will appear as the past,"[9] and he produced a body of photographs that are simultaneously very specific in time yet also timeless. Agee experimented with multiple narrative and descriptive techniques in a kind of fugal approach that, like Faulkner's multiple narratives in *The Sound and the Fury*, underscores how imagination, memory and the different ways of telling a story can change its meaning. Christenberry has made the exploration of time and memory the very keystone of his creative activity by creating his body of work over time. After almost three decades of exploring these themes, his work might be said to embody time, not simply refer to it.

Although these artists created narrowly focused and evocative descriptions of a specific place and time, their works go far beyond that actual region and era and relate to the broader tradition of southern literature and culture. In numerous interviews and essays, Eudora Welty has been particularly clear about the importance of time and place in her writing. This passage from an interview with Bill Ferris in the mid-1970s is an excellent example.

[PLACE] IS THE WHOLE FOUNDATION ON WHICH MY FICTION RESTS. IT'S A TEST. IT'S A WAY TO TEST THE VALIDITY OF WHAT YOU THINK AND SEE, AND IT ALSO SETS A STAGE....

SOMETHING SHAPES PEOPLE, AND IT'S THE WORLD IN WHICH THEY ACT THAT MAKES THEIR EXPERIENCES—WHAT THEY ACT FOR AND WHAT THEY REACT AGAINST. AND WITH ITS POPULATION, A PLACE PRODUCES THE WHOLE WORLD IN WHICH A PERSON LIVES HIS LIFE. IT FURNISHES THE ECONOMIC BACKGROUND THAT HE GROWS UP IN, AND THE FOLKWAYS AND THE STORIES THAT COME DOWN TO HIM IN HIS FAMILY. IT'S THE FOUNTAINHEAD OF HIS KNOWLEDGE AND EXPERIENCE. I THINK, OF COURSE, WE LEARN TO GROW FURTHER THAN THAT; BUT IF WE DON'T HAVE THAT BASE I DON'T KNOW WHAT WE CAN TEST FURTHER KNOWLEDGE BY. IT TEACHES YOU TO THINK, REALLY.[10]

If place sets a stage for literary characters, time becomes the driving force that moves these characters across that stage. Evans' and Agee's work catches the sharecropper families on this stage and explores their past, present and future through their environment and their different generations. In Christenberry's work the characters are ever present, but never explicitly shown; instead, they are revealed through the results of their labors, observed over time. As Welty notes, the element of time links place to our mortality.

PLACE HAS ALWAYS NURSED, NOURISHED AND INSTRUCTED MAN; HE IN TURN CAN RULE IT AND RUIN IT, TAKE IT AND LOSE IT, SUFFER IF HE IS EXILED FROM IT, AND AFTER LIVING ON IT HE GOES TO IT IN HIS GRAVE. IT IS THE STUFF OF FICTION, AS CLOSE TO OUR LIVING LIVES AS THE EARTH WE CAN PICK UP AND RUB BETWEEN OUR FINGERS, SOMETHING WE CAN FEEL AND SMELL. BUT TIME IS LIKE THE WIND OF THE ABSTRACT. BEYOND ITS ALL-PERVASIVENESS, IT HAS NO QUALITY THAT WE APPREHEND BUT RATE OF SPEED, AND OUR OWN ACTS AND THOUGHTS ARE SAID TO GIVE IT THAT. MAN CAN FEEL LOVE FOR PLACE; BUT HE IS PRONE TO REGARD TIME AS SOMETHING OF AN ENEMY.

WE ARE MORTAL: THIS IS TIME'S DEEPEST MEANING IN THE NOVEL AS IT IS TO US ALIVE. FICTION SHOWS US THE PAST AS WELL AS THE PRESENT MOMENT IN MORTAL LIGHT; IT IS AN ART SERVED BY THE INDELIBILITY OF OUR MEMORY, AND ONE EMPOWERED BY A SHARP AND PROPHETIC AWARENESS OF WHAT IS EPHEMERAL....FEELING IS SO STRONGLY AROUSED FOR WHAT ENDURES.[11]

The photographs Evans made in Alabama in the summer of 1936 are regarded as the best work of his career, and in many ways, as Alan Trachtenberg observed, they have defined how we view 1930s America.

HIS SIMULTANEOUS EXPLORATION OF CONTEMPORARY [1930s] AMERICA AND OF PHOTOGRAPHY...[CREATED] A FUSION OF VISION AND HISTORY SO CUNNING THAT, AS MANY HAVE TESTIFIED, WE CANNOT ALWAYS TELL WHETHER EVANS DISCOVERED THE PERIOD OR INVENTED IT....EVANS'S WORK BELONGS WITH BRADY'S, LEWIS HINE'S, ATGET'S, AND ROBERT FRANK'S AS FORMULATIVE DESCRIPTIONS OF A TIME AND A PLACE.[12]

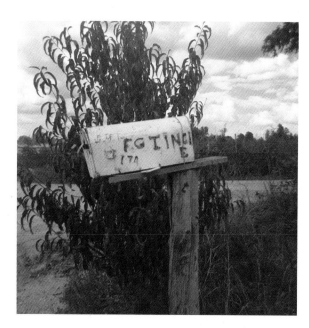

William Christenberry
TINGLE MAILBOX, CA. 1960

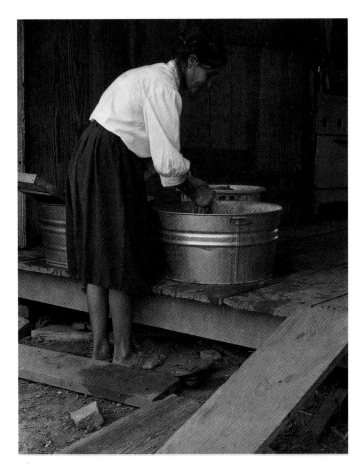

William Christenberry
ELIZABETH TINGLE, CA. 1960

Both Evans and Agee were determined to go beyond the formula of conventional documentary reporting. The editors of *Fortune* may have expected a predictably sympathetic but condescending look at the economic hardships of the southern sharecropper system, but instead Evans' photographs and Agee's text celebrated the heroicism and humanity of their sharecropper subjects, who were trapped in an unjust and brutal economic system.

The two artists' experience in Alabama was to be the greatest creative challenge of their lives. Evans, born in Saint Louis, raised in relative affluence in Chicago and educated in the East at Andover with a year at Williams, had become an intellectual rebel in the 1920s.[13] After a year's pilgrimage to Paris to live among the expatriates, this "conventional, if well-groomed bohemian," as historian John Szarkowski has called him, had returned in 1927 to settle in New York's Greenwich Village. Frustrated by his early attempts at writing, Evans turned to photography. In the late 1920s, he earned a reputation for his architectural views of eastern villages and cities and for his photographs of the Brooklyn Bridge that illustrated the 1930 edition of Hart Crane's poem, *The Bridge*. In 1935, the Resettlement Administration hired him to photograph contemporary small town and rural life, primarily in Pennsylvania and the Southeast. His photographs, like those of colleagues Dorothea Lange, Arthur Rothstein and others, were used to document the effects of the Depression on America and to promote the New Deal's remedial programs. Evans, however, bristled at the restrictions and propaganda associated with government assignments and enthusiastically took a leave to work with Agee.

Agee, having grown up in rural Tennessee, was much more comfortable with the sharecroppers' farming life than the more aristocratic Evans. He had long ago left the backcountry to study at Exeter and Harvard, however, and in recent years he had been struggling against the establishment confines of being a journalist for Henry Luce's *Fortune*. According to Evans, Agee "was in flight from New York magazine editorial offices, from Greenwich Village social-intellectual evenings, and especially from the whole world of high-minded, well-bred, money-hued culture, whether authoritarian or libertarian."[14]

Agee described his sharecropper assignment as the "best break I ever had on *Fortune*." He wrote to his former teacher and confidant, Father Flye, "[I] feel terrific responsibility toward story; considerable doubts of my ability to bring it off; considerable more of *Fortune's* ultimate willingness to use it."[15] In the modest circumstances of the tenant families, Agee felt he had found "the sources of my own life." He even wrote that the Burroughses "seemed not other than my own parents,"[16] though Allie Mae was his same age, twenty-seven, and Floyd was only four years older.

In personality, politics and art, Walker Evans was more controlled and detached than his partner. Although his response to his subjects was less personal, Evans was equally stimulated by the creative opportunities and once told Christenberry that the wealth of material was so great it "could make an artist go mad." Nonetheless, he later acknowledged, "I had a much more objective approach to artistic raw material. [Agee] was very subjective. He used to shock me. I have inhibitions about exposing the personal ego and feelings and he seems to think that is the material and that is one of the functions of an artist—exposing obscure and hidden parts of the mind and so on."[17] According to Evans, Agee "wanted to shock and scare people. He wanted to make people who were not poor, for example, really feel like what it was like to be up against it. And he wanted to rub it in."[18]

Neither artist, however, had much optimism about changing the conditions of their subjects. In contrast to conventional reformist documentary artists, who wanted their work to "help" their subjects and improve their living conditions, Evans rejected the idea as an impossibly idealistic goal, one that necessitated a superior attitude toward his subject. In later interviews he complained:

I DIDN'T LIKE THE LABEL THAT I UNCONSCIOUSLY EARNED OF BEING A SOCIAL PROTEST ARTIST. I NEVER TOOK IT UPON MYSELF TO CHANGE THE WORLD. AND THOSE CONTEMPORARIES OF MINE WHO WERE GOING AROUND FALLING FOR THE IDEA THAT THEY WERE GOING TO BRING DOWN THE UNITED STATES GOVERNMENT AND MAKE A NEW WORLD WERE JUST ASSES TO ME.[19]

In a talk to a class at Harvard in 1975, he observed:

IT'S TOO PRESUMPTUOUS AND NAIVE TO THINK YOU CAN CHANGE SOCIETY BY A PHOTOGRAPH OR ANYTHING ELSE....I

Both artists found great beauty in their Hale County subjects, in spite of the obvious poverty. As Agee observed, "There can be more beauty and more deep wonder in the standings and spacings of mute furnishings on a bare floor between the squaring bourns of walls than in any music ever made."[21] Rather than change their subjects, the two celebrated the sharecroppers' "divinity."[22] For example, both the text and the photographs capture the crude fireplaces in the Burroughs house with such clarity and respect that each object on the mantel becomes a holy relic; Agee even called the fireplaces "altars." Evans' view into the luminous, inviting space of the Burroughs' kitchen makes it seem like a serene chapel or the setting for the Last Supper. The humble collection of tableware wedged behind a board on the Fields' kitchen wall is painful evidence of their extreme poverty, but each utensil shines with an elegance and beauty that could not have been surpassed if it had been made of precious metal. Evans' photograph of Mrs. Tingle clearly reveals the uncomfortable rough weave of her dress, made of old burlap sacks, but she wears it with a dignity that transcends the crudeness of the materials. By finding beauty rather than ugliness and despair, Evans and Agee challenged conventional attitudes toward the poor and demanded that their readers and viewers change their superior attitudes and assumptions. As Lionel Trilling observed about Evans' portrait of Allie Mae Burroughs, "The gaze of the woman returning our gaze checks our pity;...[Mrs. Burroughs] with all her misery and perhaps with her touch of pity for herself, simply refuses to be an object of your 'social consciousness'."[23]

Although Evans finished his work on *Let Us Now Praise Famous Men* soon after his return from the South, Agee found it much more difficult to complete his text, which grew increasingly reflective and confessional—and lengthy—as he worked and reworked his material. When the book finally appeared, five years after their summer in Hale County and at the onset of the Second World War, it had lost all of its timeliness. Reviewers uniformly praised Evans' photographs and often recognized genius in Agee's "flawed" text, but the book was a resounding failure commercially and sold fewer than six hundred copies.[24]

However, the way in which Evans and Agee explored both the act of observing and the subject observed assured that the book's significance would extend beyond the issues of its day. Though it could not be a timely competitor for other documentary books from the 1930s, it ultimately succeeded as the most powerful critique of the documentary approach. Historian William Stott argues this in his *Documentary Expression and Thirties America*.

LET US NOW PRAISE FAMOUS MEN IS A CLASSIC OF THE THIRTIES' DOCUMENTARY GENRE. LIKE MANY ANOTHER CLASSIC, IT EPITOMIZES THE RHETORIC IN WHICH IT WAS MADE, AND EXPLODES IT, SURPASSES IT, SHOWS IT UP. HENRY JAMES ONCE OBSERVED THAT A BOOK IS EXCELLENT "IN PROPORTION AS IT STRAINS OR TENDS TO BURST, WITH A LATENT EXTRAVAGANCE, ITS MOULD," THE LITERARY FORM IN WHICH IT WAS CAST. LET US NOW PRAISE FAMOUS MEN CULMINATES THE DOCUMENTARY GENRE AND BREAKS ITS MOLD. IT REVEALS THE LIMITATIONS, THE TRAGIC SUPERFICIALITY, OF A WAY OF SEEING AND SPEAKING, OF A PERSPECTIVE ON LIFE, AND—IN SOME MEASURE, PERHAPS—OF A TIME."[25]

*Let Us Now Praise Famous Men* earned a quiet reputation as a kind of failed masterpiece, one of the classic works of the Depression, but it was not until decades later that the book found its real audience. In 1960, five years after Agee's untimely death, a second edition of *Let Us Now Praise Famous Men* was published with an expanded selection of Evans' photographs. The emerging social consciousness of the early 1960s provided a welcome environment for Agee's and Evans' concerns, and the experimental form that had seemed so awkward to some early reviewers was received more sympathetically in a period of widespread experimentation, when Agee had attained an almost cult-like status. In fact, the self-confessional, participatory approach earned the book recognition as a precursor of the "New Journalism" that began to flourish later in the sixties.

Regardless of its literary merits, *Let Us Now Praise Famous Men*, not surprisingly, was received coolly in Hale County, to the limited extent that it was acknowledged at all. The local library had a copy of it, but it was regarded as "that communist book." The poor families that Agee and Evans had made the subject of their study were not regarded as

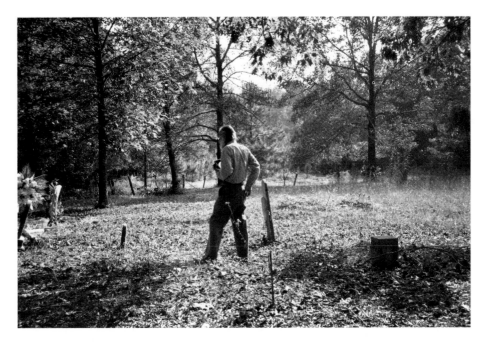

William Christenberry
WALKER EVANS IN HALE COUNTY, 1973

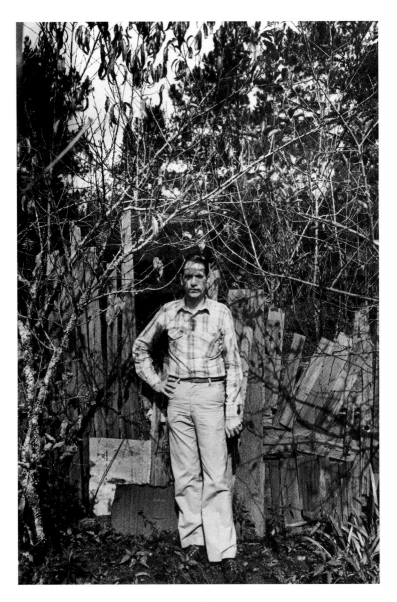

Lee Friedlander
WILLIAM CHRISTENBERRY NEAR SPRINGHILL CEMETERY
HALE COUNTY, 1983

typical or worthy of that kind of attention; the shunning and prejudice against the Tingle family—who, as Agee noted, were regarded as particularly dirty, immoral and contemptuous of community standards—continues to this day.

When William Christenberry brought home a copy of the second edition in 1960, he showed it to his grandmother Smith, who recognized Mrs. Tingle and helped him identify many other people and locations in Evans' photographs. While she was pleased to assist him, she found it difficult to understand or share his enthusiasm for looking into the lives of these disadvantaged families. In a similar vein, his mother was later perplexed that her son continued to photograph shacks but ignored all the fine antebellum homes for which Hale County was known.

Christenberry, like most perceptive readers, was responding to more than facts about specific families. Although he sought out some surviving family members and asked them about their experiences with Evans and Agee, he was very respectful of their privacy, unlike many other reporters who had followed in the same footsteps. He was not concerned with many details that recent journalists have exposed: stories of continued poverty and sickness, incest, family squabbles and after-the-fact resentment toward Evans and Agee. Instead, he was first attracted to the virtues and strengths, the "divinity" as Agee put it, presented in their book—qualities he continues to celebrate. Like his own rich memories, the stories he had learned of the Smith and Christenberry families, and the southern literature he cherished, *Let Us Now Praise Famous Men* provided a usable past from which he could draw additional inspiration to help him understand the history and meaning of his native Alabama and of life in general.

While Christenberry is almost obsessed with the past and with his childhood memories, he does not want his work to be interpreted as nostalgic in the sense of a longing for the past. He embraces sentiment, but rather than nostalgia he looks to the past to find how we have developed our values and learned to think and live. In *Let Us Now Praise Famous Men*, Christenberry found the sense of place and time, belonging and community, perseverance and strength in the midst of hardship and despair that he had loved in other works of literature; Agee and Evans had drawn these qualities out of the very soil and people that Christenberry knew.

When he first began reexploring the territory they had described, he made some photographs recreating Evans' exact vantage point, but more often Christenberry found himself attracted to new perspectives and to recording the way the subjects appeared in his own time. His photographs effectively incorporated the histories of the tenant families into his history; the art, perceptions and experiences of Agee, Evans and their sharecropper subjects merged with his own past. As he explored the changed environment, Christenberry came to reexamine familiar places and developed new insights into his roots.

Although at first he maintained a casual attitude toward his Brownie photographs, meeting Walker Evans in 1961 inspired him to take them more seriously. Challenged by his mentor and painting professor, Mel Price, to get out of Alabama, Christenberry spent a year in New York after graduate school. The time was not artistically productive for his painting—"it was the only dry spell I've ever had"—and at first he hesitated to contact Evans, a senior editor at *Fortune*. Eventually, however, Christenberry called and introduced himself as an artist from Alabama who knew some of the families and subjects from *Let Us Now Praise Famous Men*. Evans was pleased to meet the young man and even helped him get a job as a file clerk at Time-Life. Christenberry became a frequent visitor to Evans' home, and they established a friendship that lasted until Evans' death in 1975. Although at first Evans dismissed Christenberry's inquiries about Agee, responding that "If you know a great man, you don't go around mouthing it openly," he eventually provided the young artist with an introduction to Mia Agee, the author's last wife, who gave Christenberry a copy of Agee's book of poetry, *Permit Me Voyage*. When Evans asked to see some of Christenberry's paintings, he also learned about the Brownie photographs that had been made as reference studies. Evans' enthusiasm for these snapshots surprised Christenberry, who "had never thought of the photographs as anything other than something I enjoyed making." He still remembers Evans' comment verbatim.

Young man, there is something about how you use that little camera, it has become a perfect exten-

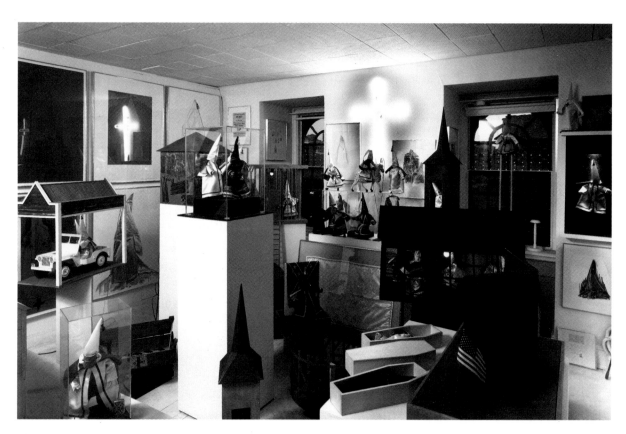

William Christenberry
**KLAN ROOM**
as installed in artist's studio, 1982
Photograph by John Tennant

SION OF YOUR EYE. YOU KNOW EXACTLY WHERE TO STAND. AND I ENCOURAGE YOU TO TAKE IT SERIOUSLY.[26]

Christenberry left New York after a year and taught at Memphis State University in Tennessee from 1962 to 1968; he was then appointed to the faculty at the Corcoran School of Art in Washington, where he continues to teach. Although he has not lived in Alabama year-round since 1961, the state remains central to his work. His visits home to family in Alabama have evolved into a kind of artistic pilgrimage that merges summer vacation and intense hard work. Unlike Walker Evans and so many photographers who can photograph freely, with meaning and insight, virtually anywhere, Christenberry feels he has to be in love with his subject, and very few places elicit the strong emotive response he gets from Hale County. However, he says that it might be too much, too intense to live there year-round. Instead, living a great distance from his primary subject matter gives a fresh perspective and a cyclical rhythm to his work and heightens his discoveries of alterations because he seldom gets to observe subtle changes as they occur. He may first become aware of a variation months after a storm knocks down a tree or building or workers finish some new construction. His working method creates an almost spiritual partnership between himself, nature and the unseen people of the county, who are the forces of change between his annual visits to evaluate their labors.

Unlike Evans and Agee, who concentrated on specific families, Christenberry hardly ever shows the people of Hale County. They are evident mostly in the results of their work and activities, rather than in their physical presence. This imbues his work with both mystery and universality and blurs distinctions of class and race. The population of Hale County is now more than sixty percent black, and many, if not the majority, of the structures Christenberry photographs have been built and used by blacks, but he might photograph a church, cemetery or store for years without knowing whether it is associated with blacks or whites. His art is an exploration of commonly shared experiences and concerns rather than a documentary study of different races and economic classes.

Where class and racial distinctions have a discernible influence on his subjects, they are reflected in his work, but these issues are not overt subjects for his photography. He has, however, attempted to deal with racial prejudice and social class in his work in other media; in 1961 he began creating a body of drawings and sculptures of Ku Klux Klan figures. Just as Evans and Agee were well aware of the flaws and imperfections of their sharecropper subjects, Christenberry has not allowed his love of the South and his community to blind him to its dark side, though he says it is "hurtful to me that the Klan is there."[27] In an environmental piece he calls the *Klan Room,* he has brought together his series of drawings and sculptures of dolls clothed in rich satin KKK gowns. They are arranged in eerie three-dimensional tableaus of figures on horses, Klan meetings, funerals and other activities. This creation, like his other work, has a way of giving physical form to an intangible feeling. We are left not with a simple polemic or documentary statement, but with a new sense of how complex and deeply rooted prejudice is; it cannot be legislated away any more than the Depression and the sharecropper system could be.

Through the 1960s and early 1970s, Christenberry worked steadily on his Brownie photography. At first his work consisted of either images in the manner of Evans, many of them in black and white, or subjects for paintings, in color for accurate reference. Modest as his early intentions were in composition and conception, however, these photographs were always fully formed as pictures, not simply fragmentary studies or documents.

Over the years, Christenberry has developed his own, very personal iconography of the Hale County landscape: the church at Sprott, the graveyards near Stewart and at the Springhill Baptist Church, Coleman's Cafe, the Green Warehouse, the Black Building and, especially, the Palmist Building. He also included sites with even more intense personal connections, such as the old Christenberry home in Stewart, which they sold in the 1950s and later was occupied by a black family who had worked for his grandparents.

The modesty of Christenberry's small-scale Brownie prints, with their soft resolution and rich color, perfectly complements these unpretentious buildings. Most were photographed head-on in that frank, direct way Christenberry shares with both Evans and snapshooters. He is interested in these buildings as social constructions, and in the

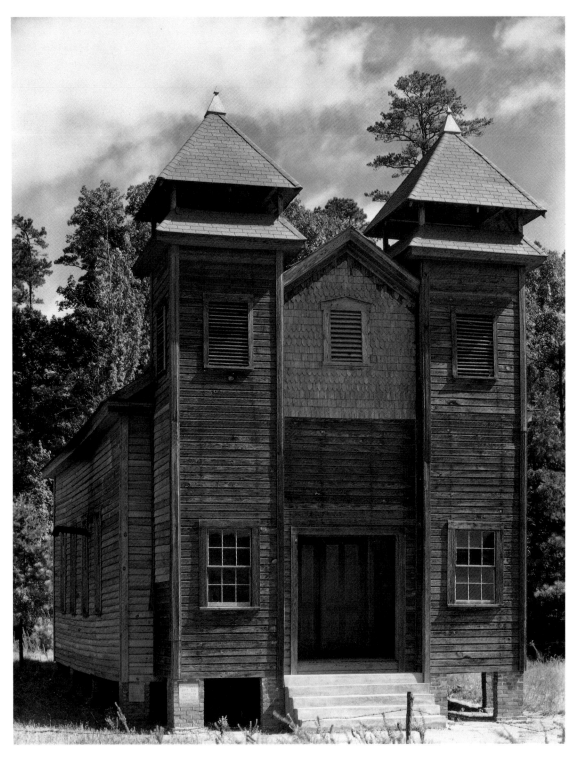

Walker Evans
CHURCH, SPROTT, 1936

space around them because architecture becomes an integral part of the landscape. In his work, the relationship between the natural and the man-made world seems in perfect harmony, and the age and decay of most of these structures further softens the distinction between what has been made by man or by God.

These qualities are explicit in such photographs as Christenberry's first image of the church at Sprott (1971). Its brilliant white facade, emphasized by the Brownie overexposure, stands majestic and monumental against a backdrop of saturated blue sky and lush green trees whose pointed tops echo the shape of the steeples. Unknown to Christenberry, Evans had also photographed this church before him, probably on the same trip that he made his famous photograph of the Sprott Post Office. Evans, however, never published his image, and the building certainly never glowed for Evans as it did for Christenberry's little Brownie camera. Both images might be described as iconic, but Christenberry's captures a loneliness and timelessness that seems especially appropriate to his concern for sentiment and memory.

The simplicity of his Brownie cameras freed Christenberry from technical concerns and allowed him to respond directly and intimately to his subject matter. This snapshot process also gave his work a sense of chance and experimentation. Even the quirks of the routine, commercially made color prints, which sometimes might exaggerate a deep blue sky or give a warm yellow cast to an image made late in the day, became important characteristics. After he began exhibiting and selling these images in 1971, he would have new prints made to match the peculiarities and character of the original drugstore prints. The Brownie's soft-focus blur also tends to blend colors and give an impression of a subject rather than a frozen description. This can be seen by Christenberry's rare use of flash in the 1962 view of the Stewart storefront, which produced a sharp, contrasty image compared to later photographs of this and other scenes made without flash. The almost ephemeral quality of the small Brownies has a way of giving form to memory.

Christenberry exhibited his Brownie photos alone for the first time in 1973, and Evans supplied a note to the exhibition text. He wrote that their lack of professionalism and their purity of vision were the qualities that most attracted him. He praised Christenberry's "breathtaking candor, ease, charm, and perfect instinct....I want to indulge myself in the truly sensual pleasure of savoring these things in their quiet honesty, subtlety, and restrained strength and in their refreshing purity. There is something enlightening about them, as ranged [sic] here: they seem to write a new little social and architectural history about one regional America (the deep South). In addition to that, each one is a poem."[28] This was high praise from someone who only a few years earlier had dismissed color photography as "vulgar" and "corrupt."[29]

Christenberry continued to photograph exclusively with his Brownie cameras until 1977, when he responded to the encouragement of photographer friends Lee Friedlander and Caldecott Chubb and shifted to a large-format, eight-by-ten Deardorff view camera. Mastering this awkward new camera was no small accomplishment for Christenberry, who previously had been oblivious to camera technique and had never even used a light meter. The view camera gave Christenberry's work an entirely different technical quality and character. Where the soft focus and saturated color of his Brownies made common buildings and scenes seem almost mythic—like inventions of the imagination rather than real buildings existing in real time—the great detail and clarity of the large-format work defines objects, spaces and colors with much greater precision. Christenberry describes this work as more panoramic, and he has tended to stand farther back from his subjects and include more of the space and environment around buildings.

Many of the structures in these large-format works seem even more lonely than those in his Brownie images. His *Kudzu and House* is almost overwhelmed by the natural environment. The photograph's composition makes the house, abandoned without evidence of a specific occupant or specific history, less a particular building than an evocation of all tenant homes one might have briefly encountered on the road. The space between the viewer and this building goes beyond physical distance into time as well, suggesting the space between the present and the past. One suspects that walking up to the house would make it dissolve like a mirage.

Like Evans and Agee, Christenberry is attracted to the common, vernacular works of architecture of Hale County. Lincoln Kirstein, in his afterword to *American Photographs*, the

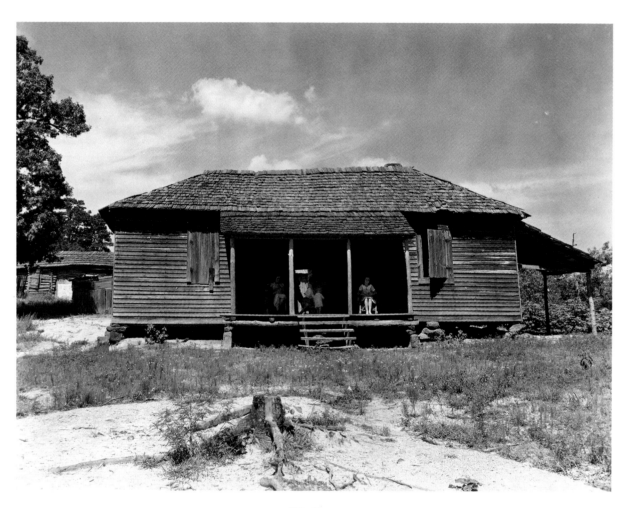

Walker Evans
BURROUGHS HOME, 1936

1938 Museum of Modern Art publication of Evans' work, observed that "our buildings are impressive only in relation to the people who built and use them....In Evans' pictures of temples or shelters the presence or absence of the people who created them is the most important thing. The structures are social rather than artistic monuments. The photographs are social documents."[30] Christenberry's interest in buildings and their makers is particularly clear in his story (see page 76) of his experience trying to photograph the house of the one-armed man to reveal "the effect of that man on that place."

A clear example of a building that reflects not just an individual, but a culture, is the abandoned dogtrot house Christenberry photographed outside Montgomery. This structure, while some eighty miles from Hale County, has connections to similar houses he remembers around his home there and to the Burroughs home in *Let Us Now Praise Famous Men*, with its open central hall, or "dogtrot," between two closed boxes. This type of building reflects its inhabitants' lives and history and also, as Eudora Welty has explained, the history of the region as "an integral part of that pioneer world. It grew as the family grew with one side added to the other."[31] In her novel *Losing Battles*, Welty describes such a house as "just what it seemed, two in one. The second house had been built side by side with the original— all a long time ago—and the space between the two had been floored over and roofed but not to this day closed in....The makings of the house had never been hidden to the Mississippi air."[32]

Christenberry has described his attraction to these buildings and his memories of them from his youth.

IT'S THE RECTANGULAR SHAPE OF IT—THE QUALITY OF THE AGE, THE WOOD—ALL THOSE THINGS APPEAL TO ME....THE THING THAT APPEALS TO ME MOST IS AGAIN THAT BASIC STRUCTURE—SUCH A SIMPLE DESIGN AND YET SO FUNCTIONAL....IT MAKES NO DIFFERENCE HOW HOT IT IS IN THE SUMMER IN THE DEEP SOUTH, INVARIABLY THERE IS A BREEZE GOING DOWN THIS OPENING HERE. AND I REMEMBER AS A CHILD VISITING PEOPLE IN THE COUNTRY. THEY'D COME IN FROM WORK IN THE COTTON FIELDS AND THERE'D ALWAYS BE A BASIN OF WATER TO WASH YOUR HANDS THERE OR BETTER STILL, A CEDAR BUCKET WITH A GOURD DIPPER WITH SPRING WATER.[33]

Of all of Christenberry's subjects, his studies of the Palmist Building perhaps best sum up how his multiple artistic concerns are expressed in different media. He has known the building since his youth and clearly remembers how it was when his Uncle Sydney operated it as a general store. But its subsequent life, first as a home for a palm reader, then abandoned with the old palmist's sign nailed to the window to keep out the elements, gives another, much more extensive life to the building. In its different states, this simple structure perfectly incorporates the qualities of real experience and imagination, personal recollection and mysterious fantasy that charge much of Christenberry's work. In his repeated examinations of the Palmist Building over time, Christenberry demonstrates that one never really knows a subject, that there is always something new to be revealed. At first the facade facing the road, the side with the upside-down palmist sign, commanded his attention; later it was the relationship of the building to its surrounding environment, especially the glorious chinaberry tree. In a rare winter visit in February 1978, when his father suffered a serious illness, the bare, dormant tree seemed to reflect some of the concern and melancholy he felt over his father's condition. A second sign was revealed in the window in 1979, and even though he knew rationally that it had always been nailed up in the window, hidden behind some old cardboard, its appearance seemed especially magical, as if it had just been created rather than merely uncovered.

Christenberry first photographed the south side of the Palmist Building in 1973 but did not begin annual pictures of its slow collapse until the late 1970s. Perhaps the character of this simpler facade became evident only after the rest of the building had been stripped of its seductive signs. The final collapse in 1988 seems to mark an end in the cycle, but the chinaberry tree still stands like a sentinel marking this ruin.

Pointing out that the changes in this building are a metaphor for the human life cycle oversimplifies Christenberry's loving study of it. The building's decay is not all that attracts the viewer to this series of photographs: the individual images also suggest mystery and enigmatic power. Even though virtually every detail of the building has been documented extensively over a long period of time, it somehow maintains its mystery and refuses to be limited by

time. Embodying the past, present and future in each image is a quality characterizing much of Christenberry's work, but it seems especially appropriate for a building that once housed a fortune teller.

Christenberry added yet another level of meaning and interpretation when he built a sculpture of the Palmist Building in 1976. In 1974, he had confessed to his friend Walter Hopps, then curator at the National Collection of Fine Arts in Washington, that his love for Sprott Church was so great that he wanted to "possess" it by building a sculpture of it. He was, however, not sure it would be worth the effort—a lack of self-assurance he would not have accepted from one of his students—until Hopps reminded him that "you cannot know until you have tried." Over several months in 1974 and 1975, Christenberry constructed his sculpture, then had his father send him some red Alabama dirt to cover the pedestal base. He knew he had achieved the effect he wanted when he exhibited this bright white church isolated on a field of red soil and a woman remarked how lonely the church appeared. He has since made fourteen more sculptures, including *Abandoned House* and *Palmist Building*. Some, like *Coleman's Cafe*, he has constructed in different versions to capture various stages of decay.

Unlike an architect's model of an idealized building plan, these studies of existing buildings try to show exactly how each has been constructed, flaws and all, and how it has aged. Like Evans' photographs, Christenberry's sculptures of buildings are social records of the people. His act of recreating them has also merged them with his personal experience and his knowledge of their history, for his eye and hand are committed to knowing and understanding these buildings and their creators rather than simply imitating them. The sculptures are products of imagination and memory, based on what he recorded and recalled about the actual appearance of each building.

Christenberry's comment that he wanted to possess the Sprott church might imply that he has a materialistic, collector's mentality, and that may be part of the attraction of collecting signs. But his sculptures are not so much for possession as for understanding through the process of recreation. In carefully retracing the activities of people who built and used the buildings and the forces that weathered them, Christenberry has made construction of his sculptures an almost religious process. His attempt to transform his intangible feelings into something material is a concrete way of merging his emotions and memories. Christenberry himself sees a surreal quality in his sculptures "that speaks to the idiosyncratic thing in building them, the lack of interest in total accuracy and precision. I want the initial impact to be like confronting the real building. But…when something is reduced way down, curious things happen."

The strong friendship and creative affinity between Evans and Christenberry was most emphatically demonstrated by their joint trip to Hale County in 1973. The University of Alabama had long been trying to get Evans there for his first visit to Alabama since his stay with Agee in 1936, and he finally accepted the invitation on the condition that Christenberry would join him for the four-day trip. Although Evans was not well, he was filled with excitement over the new camera he was using, the recently introduced Polaroid SX-70. Evans had one of the first production models of the camera. It was so new that some of his film packs had been assembled by hand rather than on the assembly line.

With Christenberry he traveled to sites like Greensboro, Sprott, Mills Hill and Stewart to see the old buildings (but not any of the surviving family members, whose privacy he still respected). He also wanted to see the new sites that Christenberry had discovered, including the cemeteries and the Palmist Building. Evans' SX-70 photograph of the sign in the Palmist Building window pays special tribute to Christenberry's work, much as Christenberry had done with Evans' photographs years earlier.

There is a wonderful symmetry that the master of the view camera had turned to a snapshot camera only a little more elaborate than Christenberry's Brownies. Even Christenberry, who certainly knew the value of simple amateur cameras, found it ironic that Evans was using only the Polaroid; he noticed that Evans had also brought along a Rolleiflex but did not remove it from his camera case the whole trip. Whether or not Evans' new-found attraction to the snapshot camera and color materials came from seeing Christenberry's work, there definitely was a fresh affinity between their creative activities. Evans liked the SX-70 for the same reasons he had praised Christenberry's earlier work with the Brownie,

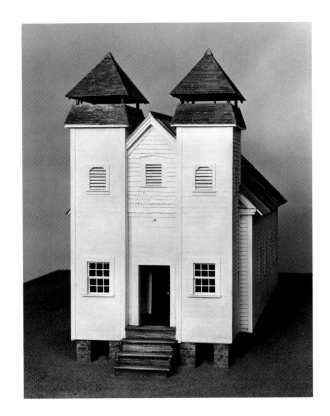

William Christenberry
**SPROTT CHURCH, 1974-1975**
Mixed media sculpture

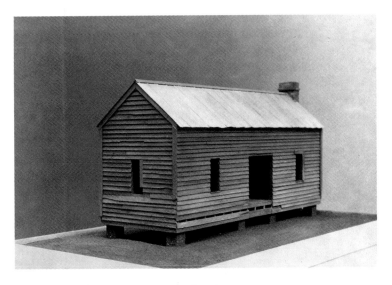

William Christenberry
**ABANDONED HOUSE, 1983**
Mixed media sculpture

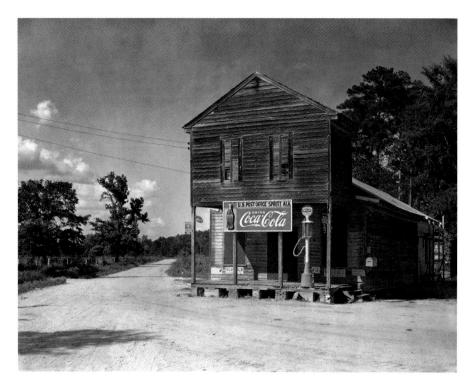

Walker Evans
POST OFFICE, SPROTT, 1936

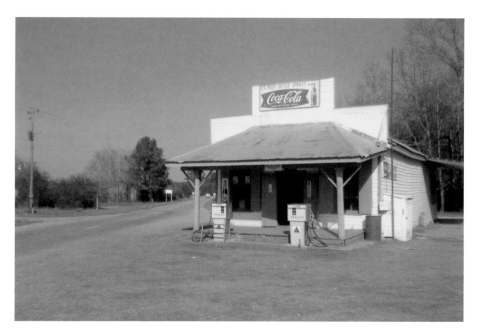

William Christenberry
U.S. POST OFFICE, SPROTT, 1971

because it offered any artist the possibility of direct and immediate seeing.

According to Jerry Thompson, one of his students at Yale at the time, Evans used the Polaroid to make many variations on each scene, as he had done before, but "he liked being able to edit (and sign) his day's work at the end of the day, without waiting to have it developed and printed. He also liked the camera's simplicity: he said several times that so streamlined a process put all responsibility on the mind and eye, leaving nothing to be added by technique."[34]

Evans was as surprised as anyone by his enthusiasm for the new camera. He talked about it in several interviews:

BUT A YEAR AGO I WOULD HAVE SAID THAT COLOR IS VULGAR AND SHOULD NEVER BE TRIED UNDER ANY CIRCUMSTANCES. IT'S A PARADOX THAT I'M NOW ASSOCIATED WITH IT AND IN FACT I INTEND TO COME OUT WITH IT SERIOUSLY....

I'M VERY EXCITED ABOUT THAT LITTLE GADGET WHICH I THOUGHT WAS JUST A TOY AT FIRST....

[I USE IT TO] EXTEND MY VISION AND LET THAT OPEN UP NEW STYLISTIC PATHS THAT I HAVEN'T BEEN DOWN YET. THAT'S ONE OF THE PECULIAR THINGS ABOUT IT THAT I UNEXPECTEDLY DISCOVERED. A PRACTICED PHOTOGRAPHER HAS AN ENTIRELY NEW EXTENSION IN THAT CAMERA. YOU PHOTOGRAPH THINGS THAT YOU WOULDN'T THINK OF PHOTOGRAPHING BEFORE. I DON'T EVEN YET KNOW WHY, BUT I FIND THAT I'M QUITE REJUVENATED BY IT....

...IT'S THE FIRST TIME, I THINK, THAT YOU CAN PUT A MACHINE IN AN ARTIST'S HAND AND HAVE HIM THEN RELY ENTIRELY ON HIS VISION AND HIS TASTE AND HIS MIND.[35]

Although Evans and Christenberry share many of the same subjects and concerns, there is a dramatic difference to the meaning of their work. Evans photographed a culture in a state of economic and spiritual crisis, while Christenberry's photographs are more like traces of timeless, mysterious forces. Their photographs of similar subjects automatically have different connotations when viewed in the age of Reagan and Bush rather than Roosevelt. Evans was most interested in capturing the unrecognized features of his era; and, to do so, he embraced contemporary vernacular subjects that still appeared new in his time, such as cars and recent types of signage. Christenberry, on the other hand, seems more interested in photographing the past as found in the present; most of his subject matter could have existed in 1930s America.

Likewise, Christenberry's photographing in the style and tradition we associate with Evans and the Great Depression has a way of pushing his works back in time.

In fact, Christenberry's subject matter is so close to the pictures that Evans created of the Depression-era South that one almost suspects him of romanticizing his subjects, as if just outside camera range are the K-Marts, strip malls, multiplex movie theaters and other features that have redefined and homogenized America and destroyed the unique character of place. But actually, Hale County looks remarkably like Evans' and Christenberry's depictions of it. If anything, it is even more quiet, now that many of the cotton fields have turned back into pine forests. There are no McDonalds; travelers still have to stop at a general store to buy a soda on a hot summer's day.

Christenberry's records of similar subjects decades after Evans and Agee worked in Hale County also give a useful new perspective to the earlier artists' underlying fatalism. Their body of work suggests that culture cannot be changed through superficial legislative remedies, and in finding and photographing the same subjects decades later, Christenberry reinforces that fatalism.

The real and the iconic Hale County coexist in a strange way. The little post office in Sprott has a changed facade but still looks remote and isolated on a dusty country road crossing. The dimly lit interior does not seem to have changed from Evans' and Agee's time. But it is not totally frozen in time: posted behind the counter is a clipping from the *New York Times* showing Evans' photograph of the store, and the store proprietor talks about the BBC film crew who had been there and the German tourists who just passed through. The tenant families have also been subjected to numerous follow-up studies and interviews, and some have come to resent the attention from outsiders. "If we are so famous," many of them have asked, "how come we are not rich?" Numerous young photographers have retraced Evans' steps, and now Christenberry's personal icons are being rephotographed by new, younger photographers.

Evans' and Christenberry's works embrace change, but change is not always for the better. Many of the churches they cared about are still vital, but all too often "improvements" have destroyed rather than enhanced their character.

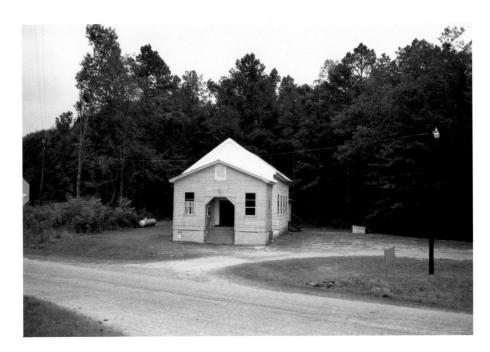

William Christenberry
CHURCH, SPROTT, 1983

The subtle curve and texture of the century-old clapboards on China Grove church have now been "corrected" by new siding with machine-made texture and perfectly parallel lines. Even more tragically, the majestic towers of the church at Sprott were removed when the porch entrance was rebuilt, ruining it, at least to Christenberry's taste.

It is not just nostalgia that regrets this change and interprets it as a loss. While one could ask why low-maintenance synthetic siding compares unfavorably to the masonry, wood and sheet metal facades that Evans and Christenberry photographed with so much emotion, the fact is that plastic and aluminum, unlike tin, wood and brick, are impervious to the elements and to change. What was once a dynamic, living building is now being killed and embalmed by the very process of preservation.

In their images of Hale County, these artists have not tried to create a document of the county, but they each share a concern for capturing that place at a specific time. As Christenberry said, "I think that oftentimes art can make an outsider look back on something he has never been a part of, and make him feel like he has always been a part of it."

William Faulkner perhaps best stated the artist's struggle with the forces of time and place:

THE AIM OF EVERY ARTIST IS TO ARREST MOTION, WHICH IS LIFE, BY ARTIFICIAL MEANS AND HOLD IT FIXED SO THAT 100 YEARS LATER WHEN A STRANGER LOOKS AT IT, IT MOVES AGAIN SINCE IT IS LIFE. SINCE MAN IS MORTAL, THE ONLY IMMORTALITY POSSIBLE FOR HIM IS TO LEAVE SOMETHING BEHIND HIM THAT IS IMPORTANT, SINCE IT WILL ALWAYS MOVE.[36]

1 Agee's account in *Let Us Now Praise Famous Men* of his and Evans' experiences in the South is not always clear or consistent. Many of the facts presented here about how they met and worked with the families are taken from interviews with Evans and from historical studies. These include:

Bill Ferris, *Images of the South: Visits with Eudora Welty and Walker Evans* (Memphis, Tennessee: Center for Southern Folklore, 1977).

William Stott, *Documentary Expression and Thirties America* (New York: Oxford University Press, 1973).

Laurence Bergreen, *James Agee: A Life* (New York: Penguin Books, 1985).

Howell Raines, "Let Us Now Revisit Famous Folk," *New York Times Magazine*, May 25, 1980.

Dale Maharidge & Michael Williamson, *And Their Children After Them* (New York: Pantheon Books, 1989).

2 Agee's text is unclear about Evans' activities. Although there are a number of passages in *Let Us Now Praise Famous Men* and comments in Evans' interviews that indicate he spent at least a few nights in the Burroughs home, John Hill, executor of the Evans estate, says that Evans kept a room at a nearby hotel and returned to it at night. This is also confirmed by Maharidge's interviews with some of the surviving members of the families (*And Their Children After Them*, 40).

3 Unless otherwise noted, information about Christenberry and quotes from him have been drawn from interviews conducted by the author in July 1988.

4 R.H. Cravens, *William Christenberry: Southern Photographs* (Millerton, N.Y.: Aperture, 1983), 6.

5 James Agee and Walker Evans, *Let Us Now Praise Famous Men*, 2d ed. (Boston: Houghton Mifflin Company, 1960), 13.

6 Christenberry used a Brownie Hawkeye camera, which made square images, and a Brownie Holiday, which made rectangular images.

7 William Faulkner interview by Jean Stein (1956), from *Writers at Work: The Paris Review Interviews, First Series*, edited by Malcolm Cowley, reprinted in *A Modern Southern Reader*, edited by Ben Forkner and Patrick Samway, S.J. (Atlanta: Peachtree Publishers, Ltd., 1986), 673.

8 *Let Us Now Praise Famous Men*, xv.

9 Jerry L. Thompson, *Walker Evans at Work* (New York: Harper and Row, 1982), 151.

10 Ferris, *Images of the South*, 15.

11 Eudora Welty, "Some Notes on Time in Fiction," *The Eye of the Story* (New York: Random House, 1979), 163.

12 Alan Trachtenberg, "The Artist of the Real," *The Presence of Walker Evans* (Boston: The Institute of Contemporary Art, 1978), 22-24.

13 The best biographical account of Evans is John Szarkowski, *Walker Evans* (New York: The Museum of Modern Art, 1971). See also Leslie Katz' interview with Walker Evans in *Art in America* 59 (March/April 1971): 83-90.

14 Walker Evans, "James Agee in 1936," foreword to second edition of *Let Us Now Praise Famous Men*, ix-xi.

15 James Agee, *Letters of James Agee to Father Flye* (New York: Bantam Books, 1962), 83.

16 *Let Us Now Praise Famous Men*, 415.

17 "Walker Evans on Himself," *New Republic*, 13 November 1976, 25.

18 Ferris, *Images of the South*, 15.

19 Walker Evans, "The Thing Itself is Such a Secret and So Unapproachable," *Image* 17, no. 4 (1974): 14.

20 "Walker Evans on Himself," 25.

21 *Let Us Now Praise Famous Men*, 134.

22 *Let Us Now Praise Famous Men*, xiv.

23 Lionel Trilling, "Greatness with One Fault in It," *Kenyon Review* 4, no. 1 (Winter 1942): 100.

24 Bergreen, *James Agee: A Life*, 257-260.

25 Stott, *Documentary Expression and Thirties America*, 266.

26 Cravens, *William Christenberry: Southern Photographs*, 13.

27 Ibid., 15, and Christenberry interview with author, July 1988.

28 Walker Evans note printed in exhibition brochure, *William Christenberry: Photographs*, April 13-May 27, 1973, Corcoran Gallery of Art, Washington, D.C.

29 Walker Evans, "Photography," *Quality: Its Image in the Arts*, edited by Louis Kronenberger (New York: Atheneum, 1969), 207-208.

30 Lincoln Kirstein, "Photographs of America: Walker Evans," in Walker Evans, *American Photographs* (New York: The Museum of Modern Art, 1938), 195.

31 William Ferris, "The Dogtrot: A Mythic Image in Southern Culture," *Southern Quarterly* 25, no. 1 (Fall 1986): 76.

32 Ibid.

33 Ibid., 80.

34 Thompson, *Walker Evans at Work*, 17.

35 Evans, "The Thing Itself," 18.

36 Forkner and Samway, eds., *A Modern Southern Reader*, 672.

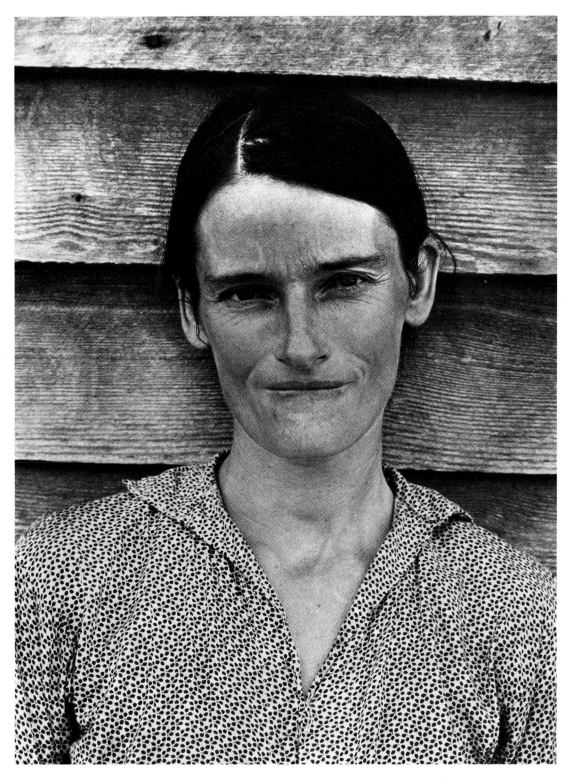

Walker Evans
ALLIE MAE BURROUGHS, WIFE OF A SHARECROPPER, 1936

GEORGE GUDGER IS A HUMAN BEING, A MAN, NOT LIKE ANY OTHER HUMAN BEING SO MUCH AS HE IS LIKE HIMSELF. I COULD INVENT INCIDENTS, APPEARANCES, ADDITIONS TO HIS CHARACTER, BACKGROUND, SURROUNDINGS, FUTURE, WHICH MIGHT WELL POINT UP AND INDICATE AND CLINCH THINGS RELEVANT TO HIM WHICH IN FACT I AM SURE ARE TRUE, AND IMPORTANT, AND WHICH GEORGE GUDGER UNCHANGED AND UNDECORATED WOULD NOT INDICATE AND PERHAPS COULD NOT EVEN SUGGEST. THE RESULT, IF I WAS LUCKY, COULD BE A WORK OF ART. BUT SOMEHOW A MUCH MORE IMPORTANT, AND DIGNIFIED, AND TRUE FACT ABOUT HIM THAN I COULD CONCEIVABLY INVENT, THOUGH I WERE AN ILLIMITABLY BETTER ARTIST THAN I AM, IS THAT FACT THAT HE IS EXACTLY, DOWN TO THE LAST INCH AND INSTANT, WHO, WHAT, WHERE, WHEN AND WHY HE IS. HE IS IN THOSE TERMS LIVING, RIGHT NOW, IN FLESH AND BLOOD AND BREATHING, IN AN ACTUAL PART OF A WORLD IN WHICH ALSO, QUITE AS IRRELEVANT TO IMAGINATION, YOU AND I ARE LIVING. GRANTED THAT BESIDE THAT FACT IT IS A SMALL THING, AND GRANTED ALSO THAT IT IS ESSENTIALLY AND FINALLY A HOPELESS ONE, TO TRY MERELY TO REPRODUCE AND COMMUNICATE HIS LIVING AS NEARLY EXACTLY AS POSSIBLE, NEVERTHELESS I CAN THINK OF NO WORTHIER AND MANY WORSE SUBJECTS OF ATTEMPT.

JAMES AGEE

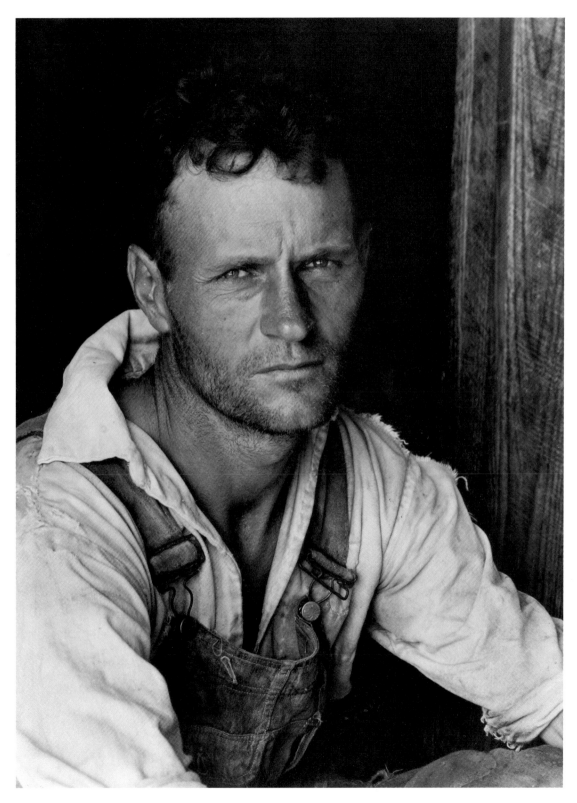

Walker Evans
FLOYD BURROUGHS, SHARECROPPER, 1936

THE GUDGERS' HOUSE, BEING YOUNG, ONLY EIGHT YEARS OLD, SMELLS A LITTLE DRYER AND CLEANER, AND MORE DISTINCTLY OF ITS WOOD, THAN AN AVERAGE WHITE TENANT HOUSE, AND IT HAS ALSO A CERTAIN ODOR I HAVE NEVER FOUND IN OTHER SUCH HOUSES: ASIDE FROM THESE SHARP YET SLIGHT SUBTLETIES, IT HAS THE ODOR OR ODORS WHICH ARE CLASSICAL IN EVERY THOROUGHLY POOR WHITE SOUTHERN COUNTRY HOUSE, AND BY WHICH SUCH A HOUSE COULD BE IDENTIFIED BLINDFOLD IN ANY PART OF THE WORLD, AMONG NO MATTER WHAT OTHER ODORS. IT IS COMPACTED OF MANY ODORS AND MADE INTO ONE, WHICH IS VERY THIN AND LIGHT ON THE AIR, AND MORE SUBTLE THAN IT CAN SEEM IN ANALYSIS, YET VERY SHARPLY AND CONSTANTLY NOTICEABLE. THESE ARE ITS INGREDIENTS. THE ODOR OF PINE LUMBER, WIDE THIN CARDS OF IT, HEATED IN THE SUN, IN NO WAY DOUBLED OR INSULATED, IN CLOSED AND DARKENED AIR. THE ODOR OF WOODSMOKE, THE FUEL BEING AGAIN MAINLY PINE, BUT IN PART ALSO, HICKORY, OAK, AND CEDAR. THE ODORS OF COOKING. AMONG THESE, MOST STRONGLY, THE ODORS OF FRIED SALT PORK AND OF FRIED AND BOILED PORK LARD, AND SECOND, THE ODOR OF COOKED CORN. THE ODORS OF SWEAT IN MANY STAGES OF AGE AND FRESHNESS, THIS SWEAT BEING A DISTILLATION OF PORK, LARD, CORN, WOODSMOKE, PINE, AND AMMONIA. THE ODORS OF SLEEP, OF BEDDING AND OF BREATHING, FOR THE VENTILATION IS POOR. THE ODORS OF ALL THE DIRT THAT IN THE COURSE OF TIME CAN ACCUMULATE IN A QUILT AND MATTRESS. ODORS OF STALENESS FROM CLOTHES HUNG OR STORED AWAY, NOT WASHED. J.A.

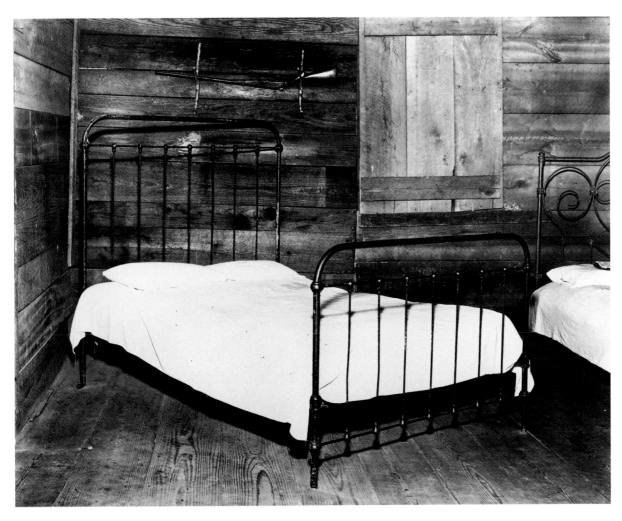

Walker Evans
BEDROOM, BURROUGHS HOME, 1936

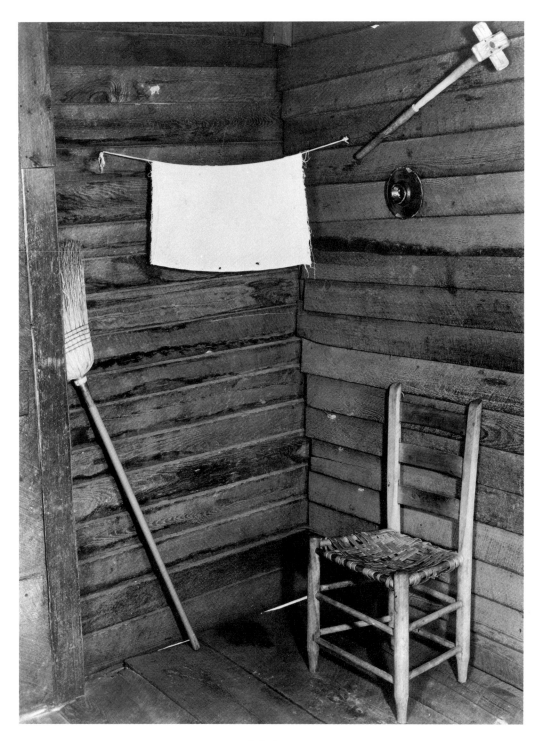

Walker Evans
KITCHEN CORNER BURROUGHS HOME, 1936

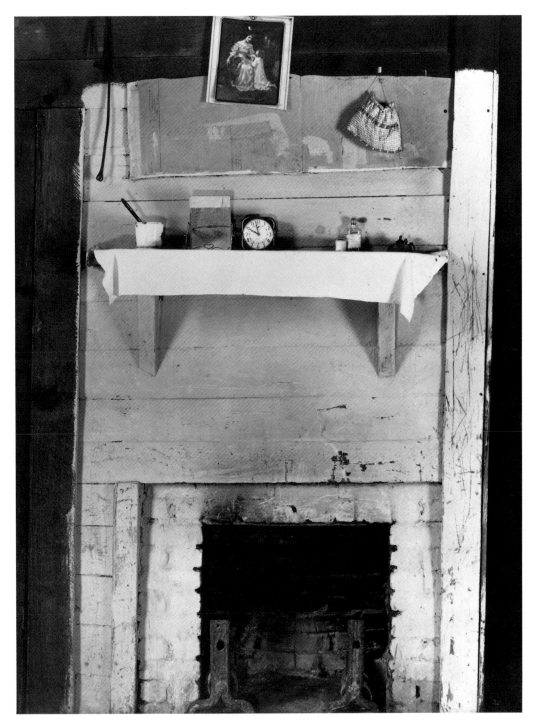

Walker Evans
FIREPLACE, BURROUGHS BEDROOM, HALE COUNTY, SUMMER 1936

ON THE MANTEL AGAINST THE GLOWING WALL, EACH ABOUT SIX INCHES FROM THE ENDS OF THE SHELF, TWO SMALL TWIN VASES, VERY SIMPLY BLOWN, OF PEBBLE-GRAINED IRIDESCENT GLASS. EXACTLY AT CENTER BETWEEN THEM, A FLUTED SAUCER, WITH A COARSE LACE EDGE, OF PRESSED MILKY GLASS, WHICH LOUISE'S MOTHER GAVE HER TO CALL HER OWN AND FOR WHICH SHE CARES MORE DEARLY THAN FOR ANYTHING ELSE SHE POSSESSES. PINNED ALL ALONG THE EDGE OF THIS MANTEL, A BROAD FRINGE OF WHITE TISSUE PATTERN-PAPER WHICH MRS. GUDGER FOLDED MANY TIMES ON ITSELF AND SCISSORED INTO PIERCED GEOMETRICS OF LACE, AND OF WHICH SHE SPEAKS AS HER LAST EFFORT TO MAKE THIS HOUSE PRETTY. J.A.

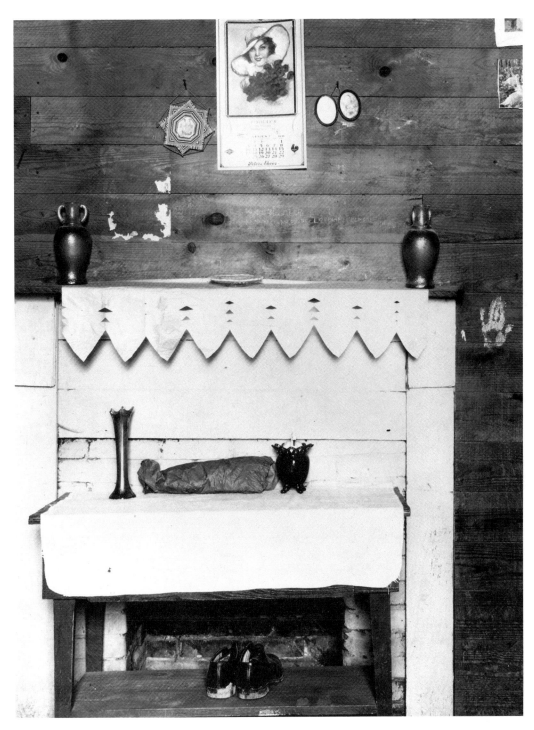

Walker Evans
FIREPLACE, BURROUGHS HOME, 1936

THE ONE STATIC FIXTURE IN THE HALLWAY IS AT THE REAR, JUST BEYOND THE KITCHEN DOOR. IT IS A WOODEN SHELF, WAIST-HIGH, AND ON THIS SHELF, A BUCKET, A DIPPER, A BASIN, AND USUALLY A BAR OF SOAP, AND HANGING FROM A NAIL JUST ABOVE, A TOWEL. THE BASIN IS GRANITE-WARE, SMALL FOR A MAN'S HANDS, WITH RUST-MARKS IN THE BOTTOM. THE BUCKET IS A REGULAR GALVANIZED TWO-GALLON BUCKET, A LITTLE DENTED, AND SMELLING AND TOUCHING A LITTLE OF A FISHY-METALLIC KIND OF SHINE AND GREASE BEYOND ANY POWER OF CLEANING. IT IS HALF FULL OF SLOWLY HEATING WATER WHICH WAS NOT VERY COLD TO BEGIN WITH: MUCH LOWER THAN THIS, THE WATER TASTES A LITTLE TICKLISH AND NASTY FOR DRINKING, THOUGH IT IS STILL ALL RIGHT FOR WASHING. THE SOAP IS SOMETIMES STRONG TAN "KITCHEN" SOAP, SOMETIMES A CHEAP WHITE GELATINOUS LAVENDER FACE SOAP. IT STANDS ON THE SHELF IN A CHINA SAUCER. THE DIPPER AGAIN IS GRANITE-WARE, AND AGAIN BLISTERED WITH RUST AT THE BOTTOM. SOMETIMES IT BOBS IN THE BUCKET; SOMETIMES IT LIES NEXT THE BUCKET ON THE SHELF. THE TOWEL IS HALF A FLOURSACK, WITH THE BLUE AND RED AND BLACK PRINTING STILL FAINT ON IT. TAKEN CLEAN AND DRY, IT IS THE PLEASANTEST CLOTH I KNOW FOR A TOWEL. BEYOND THAT, IT IS PARTICULARLY CLAMMY, CLINGING, AND DIRTY-FEELING....

THE TABLE IS SET FOR DINNER.

THE YELLOW AND GREEN CHECKED OILCOTH IS WORN THIN AND THROUGH AT THE CORNERS AND ALONG THE EDGES OF THE TABLE AND ALONG THE RIDGED EDGES OF BOARDS IN THE TABLE SURFACE, AND IN ONE OR TWO PLACES, WHERE ELBOWS HAVE RESTED A GREAT DEAL, IT IS RUBBED THROUGH IN A WIDE HOLE. IN ITS INTACT SURFACES IT SHINES PRETTILY AND BLUNTLY REFLECTS THE WINDOW AND PARTS OF THE OBJECTS THAT ARE ON IT, FOR IT HAS BEEN CAREFULLY POLISHED WITH A WET RAG, AND IT SHOWS ALSO THE TRACINGS OF THIS RAG. WHERE IT HAS RUBBED THROUGH, THE WOOD IS SOUR AND GREASY, AND THERE ARE BREAD CRUMBS IN THE SEAMS AND UNDER THE EDGES OF THE CLOTH, WHICH SMELL OF MOLD, AND THESE ODORS ARE SO MINGLED WITH THAT OF THE OILCLOTH THAT THEY ARE IN TOTAL THE CLASSIC ODOR OF A TENANT EATING-TABLE.  J.A.

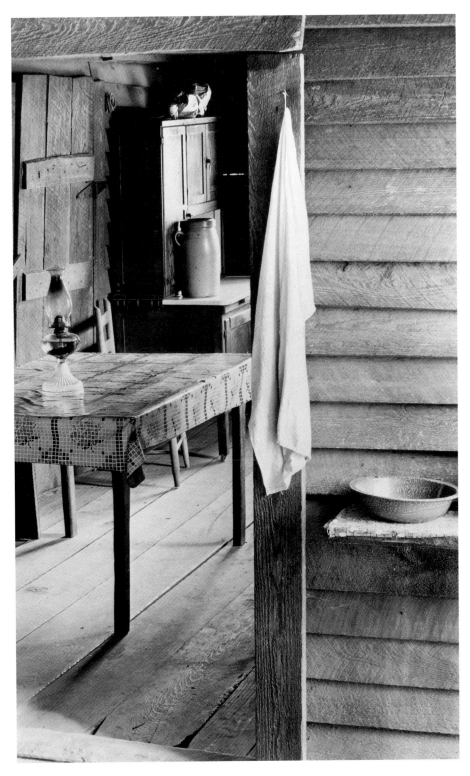

Walker Evans
KITCHEN, BURROUGHS HOME, 1936

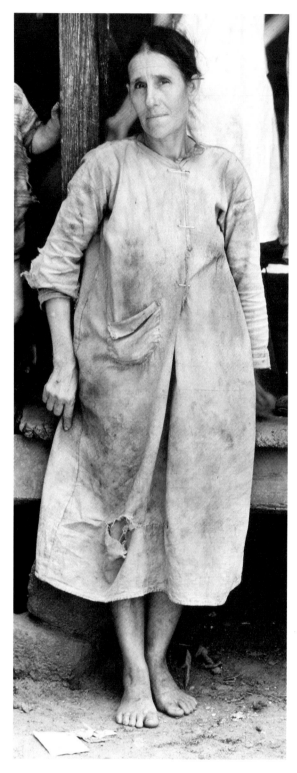

Walker Evans
MRS. FRANK TINGLE, WIFE OF A SHARECROPPER, 1936

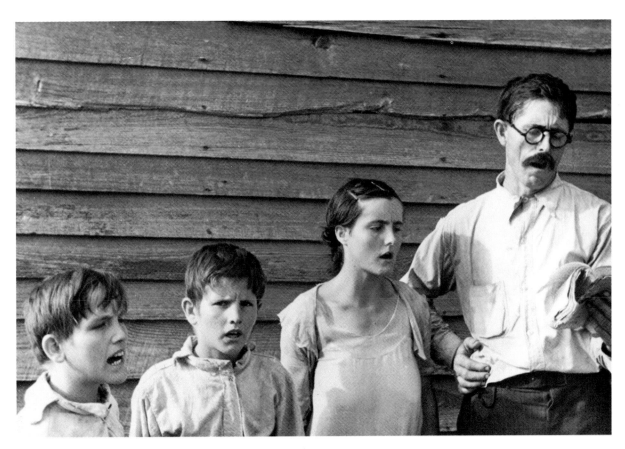

Walker Evans
Frank Tingle Family, Sunday Singing, 1936

HERE I MUST SAY, A LITTLE ANYHOW: WHAT I CAN HARDLY HOPE TO BEAR OUT IN THE RECORD: THAT A HOUSE OF SIMPLE PEOPLE WHICH STANDS EMPTY AND SILENT IN THE VAST SOUTHERN COUNTRY MORNING SUNLIGHT, AND EVERYTHING WHICH ON THIS MORNING IN ETERNAL SPACE IT BY CHANCE CONTAINS, ALL THUS LEFT OPEN AND DEFENSELESS TO A REVERENT AND COLD-LABORING SPY, SHINES QUIETLY FORTH SUCH GRANDEUR, SUCH SORROWFUL HOLINESS OF ITS EX-ACTITUDES IN EXISTENCE, AS NO HUMAN CONSCIOUSNESS SHALL EVER RIGHTLY PERCEIVE, FAR LESS IMPART TO AN-OTHER: THAT THERE CAN BE MORE BEAUTY AND MORE DEEP WONDER IN THE STANDINGS AND SPACINGS OF MUTE FUR-NISHINGS ON A BARE FLOOR BETWEEN THE SQUARING BOURNS OF WALLS THAN IN ANY MUSIC EVER MADE: THAT THIS SQUARE HOME, AS IT STANDS IN UNSHADOWED EARTH BETWEEN THE WINDING YEARS OF HEAVEN, IS, NOT TO ME BUT OF ITSELF, ONE AMONG THE SERENE AND FINAL, UNCAPTURABLE BEAU-TIES OF EXISTENCE: THAT THIS BEAUTY IS MADE BETWEEN HURT BUT INVINCIBLE NATURE AND THE PLAINEST CRUEL-TIES AND NEEDS OF HUMAN EXISTENCE IN THIS UNCURED TIME, AND IS INEXTRICABLE AMONG THESE, AND AS IMPOS-SIBLE WITHOUT THEM AS A SAINT BORN IN PARADISE. J.A.

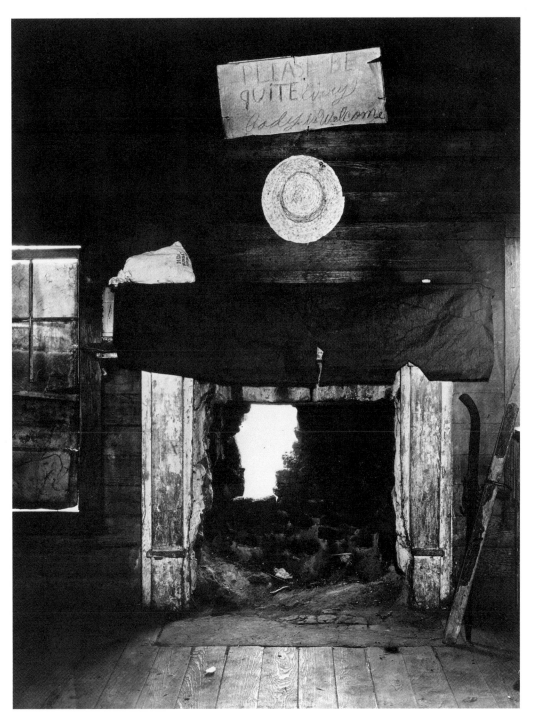

Walker Evans
THE COTTON ROOM, TINGLE FARM, 1936

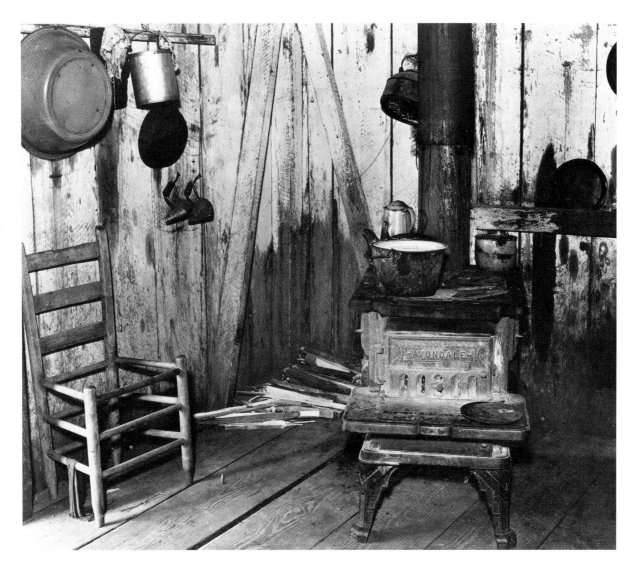

Walker Evans
KITCHEN, FIELDS HOME, 1936

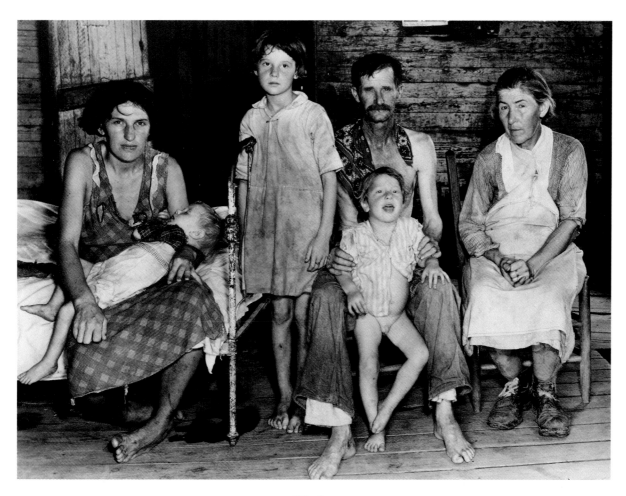

Walker Evans
BUD FIELDS FAMILY, 1936

ON SYMMETRY: THE HOUSE IS RUDIMENTARY AS A CHILD'S DRAWING, AND OF A BARENESS, CLEANNESS, AND SOBRIETY WHICH ONLY DORIC ARCHITECTURE, SO FAR AS I KNOW, CAN HOPE TO APPROACH: THIS EXACT SYMMETRY IS SPRUNG SLIGHTLY AND SUBTLY, HERE AND THERE, ONE CORNER OF THE HOUSE A LITTLE OFF VERTICAL, A COURSE OF WEATHERBOARDING FAILING THE HORIZONTAL BETWEEN PARALLELS, A WINDOW FRAME NOT QUITE SQUARE, BY LACK OF SKILL AND BY WEIGHT AND WEAKNESS OF TIMBER AND TIME; AND THESE SLIGHT FAILURES, THEIR TENSIONS SPRUNG AGAINST CENTERS AND OPPOSALS OF SUCH RIGID AND EARNEST EXACTITUDE, SET UP INTENSITIES OF RELATIONSHIP FAR MORE POWERFUL THAN FULL SYMMETRY, OR STUDIED DISSYMMETRY, OR USE OF RELIEF OR ORNAMENT, CAN EVER BE: INDEED, THE POWER IS OF ANOTHER WORLD AND ORDER THAN THEIRS, AND THERE IS, AS I MENTIONED, A PARTICULAR QUALITY OF A THING HAND-MADE, WHICH BY COMPARISON I CAN BEST SUGGEST THUS: BY THE GRANDEUR THAT COMES OF THE EFFORT OF ONE MAN TO HOLD TOGETHER UPON ONE INSTRUMENT, AS IF HE WERE BREAKING A WILD MONSTER TO BRIDLE AND RIDING, ONE OF THE LARGER FUGUES OF BACH, ON AN ORGAN, AS AGAINST THE SLICK COLLABORATIONS AND EFFORTLESS CLIMAXES OF THE SAME PIECE IN THE MANIPULATIONS OF AN ORCHESTRA. J.A.

Walker Evans
KITCHEN WALL, FIELDS HOME, 1936

IT IS MY BELIEF THAT SUCH HOUSES AS THESE APPROXI-MATE, OR AT TIMES BY CHANCE ACHIEVE, AN EXTRAORDINARY "BEAUTY."...

THE HOUSES ARE BUILT IN THE "STINGINESS," CARE-LESSNESS, AND TRADITIONS OF AN UNPERSONAL AGENCY; THEY ARE OF THE ORDER OF "COMPANY" HOUSES. THEY ARE FURNISHED, DECORATED AND USED IN THE STARVED NEEDS, TRADITIONS AND NAIVETIES OF PROFOUNDLY SIMPLE INDIVIDUALS. THUS THERE ARE CONVEYED HERE TWO KINDS OF CLASSICISM, ESSENTIALLY DIFFERENT YET RELATED AND BEAUTIFULLY EUPHONIOUS. THESE CLASSICISMS ARE CRE-ATED OF ECONOMIC NEED, OF LOCAL AVAILABILITY, AND OF LOCAL-PRIMITIVE TRADITION: AND IN THEIR PURITY THEY ARE THE EXCLUSIVE PROPERTY AND PRIVILEGE OF THE PEOPLE AT THE BOTTOM OF THAT WORLD. TO THOSE WHO OWN AND CREATE IT THIS "BEAUTY" IS, HOWEVER, IRRELEVANT AND UNDISCERNIBLE. IT IS BEST DISCERNIBLE TO THOSE WHO BY ECONOMIC ADVANTAGES OF TRAINING HAVE ONLY A SHAMEFUL AND THIEF'S RIGHT TO IT: AND IT MIGHT BE SAID THAT THEY HAVE ANY "RIGHTS" WHATEVER ONLY IN PRO-PORTION AS THEY RECOGNIZE THE UGLINESS AND DISGRACE IMPLICIT IN THEIR PRIVILEGE OF PERCEPTION. J.A.

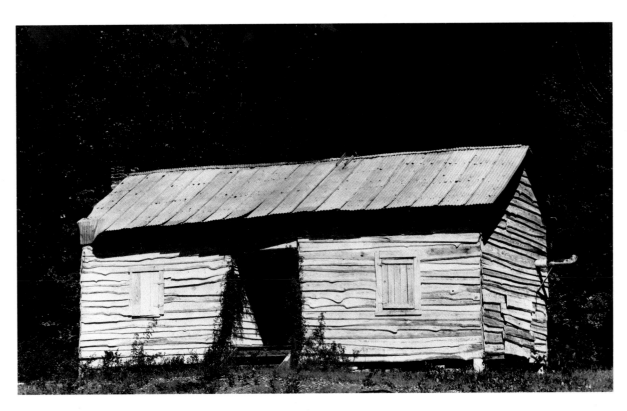

Walker Evans
NEGRO SHARECROPPER'S CABIN, 1936

WHEN THE GRAVE IS STILL YOUNG, IT IS VERY SHARPLY DISTINCT, AND OF A PECULIAR FORM. THE CLAY IS RAISED IN A LONG AND NARROW OVAL WITH A SHARP RIDGE, THE SHAPE EXACTLY OF AN INVERTED BOAT. A FAIRLY BROAD BOARD IS DRIVEN AT THE HEAD; A NARROWER ONE, SOMETIMES ONLY A STOB, AT THE FEET....

A GREAT MANY OF THESE GRAVES, PERHAPS HALF TO TWO THIRDS OF THOSE WHICH ARE STILL DISTINCT, HAVE BEEN DECORATED, NOT ONLY WITH SHRUNKEN FLOWERS IN THEIR CRACKED VASES AND WITH BENT TARGETS OF BLASTED FLOWERS, BUT OTHERWISE AS WELL. SOME HAVE A LINE OF WHITE CLAMSHELLS PLANTED ALONG THEIR RIDGE; OF OTHERS, THE RIM AS WELL IS GARLANDED WITH THESE SHELLS. ON ONE LARGE GRAVE, WHICH IS OTHERWISE COMPLETELY PLAIN, A BLOWN-OUT ELECTRIC BULB IS SCREWED INTO THE CLAY AT THE EXACT CENTER. ON ANOTHER, ON THE SLOPE OF CLAY JUST IN FRONT OF THE HEADBOARD, ITS FEET NEXT THE BOARD, IS A HORSESHOE; AND AT ITS CENTER A BLOWN BULB IS STOOD UPRIGHT. ON TWO OR THREE OTHERS THERE ARE INSULATORS OF BLUE-GREEN GLASS. ON SEVERAL GRAVES, WHICH I PRESUME TO BE THOSE OF WOMEN, THERE IS AT THE CENTER THE PRETTIEST OR THE OLDEST AND MOST VALUED PIECE OF CHINA: ON ONE, A BLUE GLASS BUTTER DISH WHOSE COVER IS A SETTING HEN; ON ANOTHER, AN INTRICATE MILK-COLORED GLASS BASKET; ON OTHERS, TEN-CENT-STORE CANDY DISHES AND IRIDESCENT VASES; ON ONE, A PATTERN OF WHITE AND COLORED BUTTONS. ON OTHER GRAVES THERE ARE SMALL AND THICK WHITE BUTTER DISHES OF THE SORT WHICH ARE USED IN LUNCH-ROOMS, AND BY THE ACTION OF RAIN THESE STAND FREE OF THE GRAVE ON SLENDER TURRETS OF CLAY. J.A.

Walker Evans
CHILD'S GRAVE, 1936

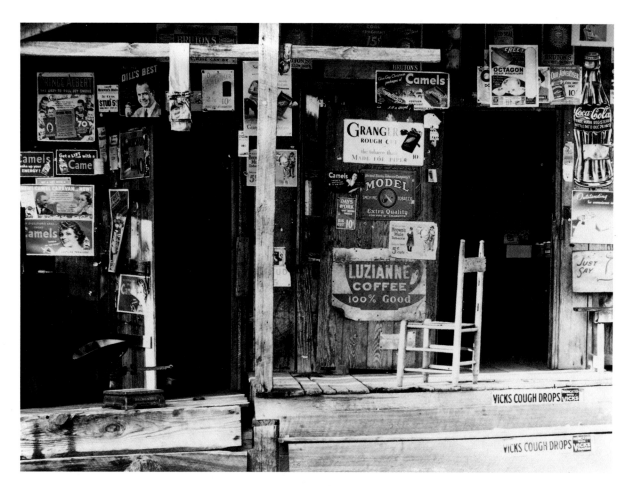

Walker Evans
COUNTRY STORE, VICINITY MOUNDVILLE, 1936

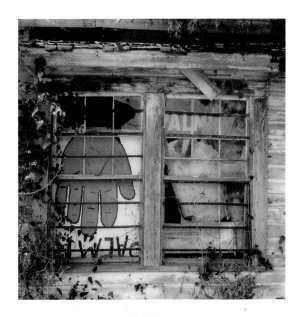

Walker Evans
PALMIST BUILDING WINDOW, 1973

Walker Evans
TOP'S SNUFF SIGN, 1973

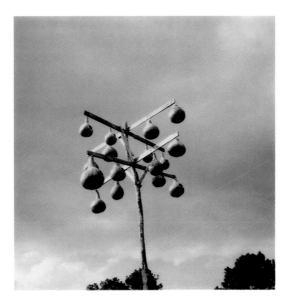

Walker Evans
GOURD TREE, 1973

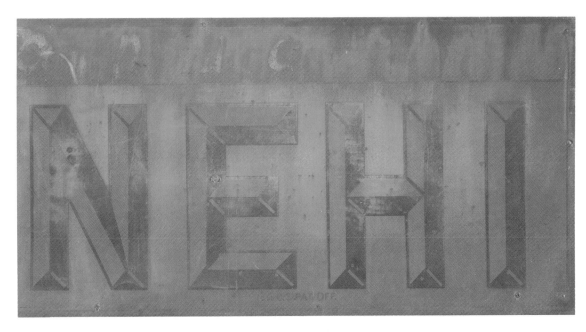

**NEHI SIGN**
Removed by William Christenberry from Stewart Cotton Warehouse in 1966
Photograph by Gregory R. Staley and William Christenberry

The Christenberrys came to Hale County from Perry County in 1916, when my father was four, not that long ago, really. I don't know exactly when my mother's family came to Hale County, but they had been in that part of the country a long time.

And the family's involvement or attachment with that county and that place can't help but affect the way I see it. A lot of blood, sweat, and tears, to use that cliché, has gone into that landscape by these families—hard-working, deeply committed people. And there are many strong, profound memories attached to that for me.

Like seeing my grandfather Smith, late in his life in his sixties, baptized in a creek. A total immersion baptism, which is pretty traumatic for a young person to see. And then going to that same creek and crossing that same creek and that same spot for close to fifty years. Over all this time, I looked at it every year, set up the camera in the last two or three years, but never yet have I photographed it. I can't make a picture of it.

Knowing the many hardships and pleasures that both families went through, there are many inspirations for going back again to the childhood memories of my experiences there and going there every year and seeing these changes in the landscape and the people. And now, realizing my own mortality as I get older, these things become even more intense.

I cannot express—I wish I could—my deep attachment for that place. For someone who has never really toiled there, never spent a lot of his life working there, eking out a living, this may be difficult to understand. But I have a very clear and sometimes terrifying and certainly intense view of it. And I think that oftentimes art can make an outsider look back on something he has never been a part of, and make him feel like he has always been a part of it.          William Christenberry

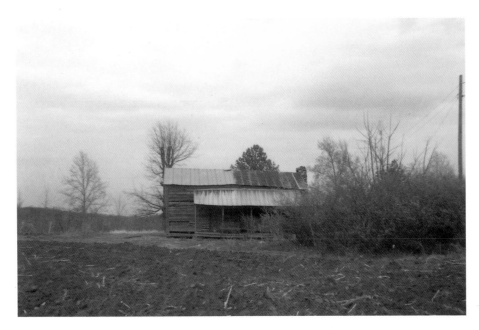

William Christenberry
FIELDS HOUSE, 1964

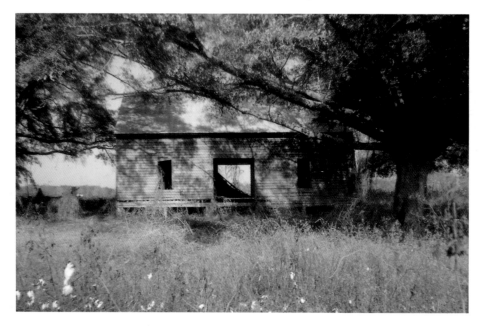

William Christenberry
ABANDONED HOUSE IN FIELD, NEAR MONTGOMERY, ALABAMA, 1971

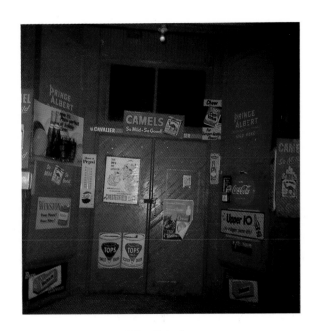

William Christenberry
STORE FRONT, STEWART, 1962

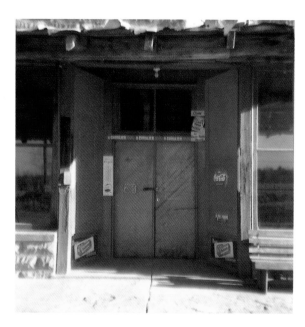

William Christenberry
STORE FRONT, STEWART, 1964

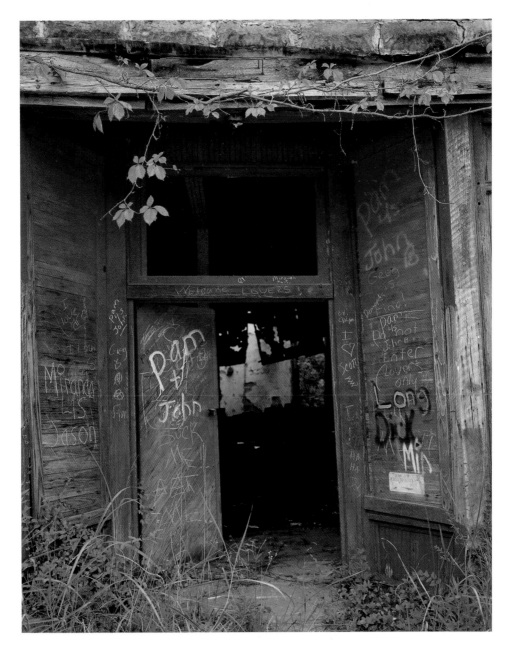

William Christenberry
STORE FRONT, STEWART, 1988

OLD MAN: You get old and you can't do anybody any good anymore.

BOY: You do me some good grandpa. You tell me things.

<div align="right">Robert Penn Warren<br>Dedication to <em>Being Here, Poetry, 1977-1980</em></div>

That passage has always meant a lot to me. It reminds me of experiences I had with my grandfathers. Sometimes a gentle reprimand or warning, on the part of my grandfather Smith when I used to run into the kudzu patch near the house and chase hens and kittens, not knowing any better. He caught me one day and called me over to the side of the road. He was a very gentle man, not like my grandfather Christenberry, who was a strong, loud, more aggressive type. But my grandfather Smith put his hand on my shoulder and said, "Son, don't go out into that kudzu. There is a snake that lives there. When it gets upset it takes its tail in its mouth and comes out like a hoop and it will roll right after you." And to this day when I see kudzu I think of hoop snakes. It's a wonderful memory. I couldn't have been any older than ten, but it is just as vivid today. W.C.

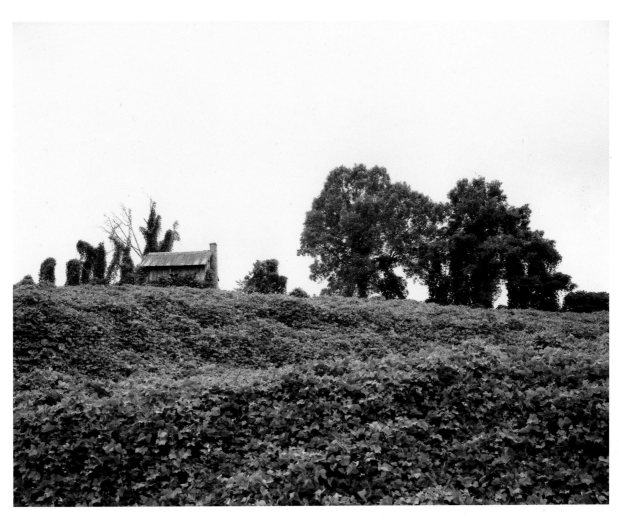

William Christenberry
KUDZU AND HOUSE, TUSCALOOSA COUNTY, 1979

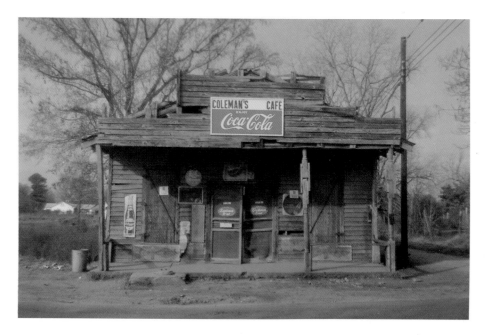

William Christenberry
COLEMAN'S CAFE, GREENSBORO, 1971

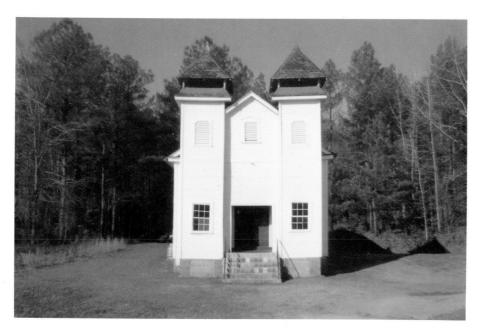

William Christenberry
CHURCH, SPROTT, 1971

Springhill Baptist Church is about twenty odd miles to the east of Greensboro, still in Hale County. You have the church here, a white, simple church, and twenty yards out there you see this rise in the landscape, a chain link fence around it, you see this cemetery. It's almost all red earth with white sand. I speculate, though I don't know for a fact, that these people had dump trucks of white sand brought in and used this to decorate the graves. So you'd have a mound of red earth—the old grave mounds could be quite old—with the mound there and this white sand all around it. The new graves have the same kind of motif. I was caught there one day in a strong thunderstorm. I had to sit in a car until it cleared, but I could see the white sand and the red earth run together and form this pinkish lavender cast.

These people, according to their fundamentalist belief, maintain what they call a clean cemetery. That is, they don't allow much vegetation to grow there. There are a few plants. There are some exquisite crape myrtle bushes or trees there that in the heat of the summer are always in bloom—pink and lavender crape myrtle. But very little grass, and that's according to their beliefs. So they will rake that cemetery, clean it, not unlike an oriental garden. And then you have this profusion of artificial flowers. I have never liked artificial flowers personally, but when you see them in that context and in relation to the egg cartons, the flowers are quite beautiful. Just color….

Oftentimes, and this is still the case, you'll find a grave where an object that the deceased cared about, loved, would be placed on the grave. What is really sad are children's graves—you'll see plastic toys. I have one picture, you have to look carefully for it, but in it is a tiny red-plastic football player, you know those things that stand up like little soldiers. Another grave has a beautiful lavender glass pitcher like I used to see a lot of, when I was a kid, as a container for iced tea. In this cemetery in particular you'll see a lot of that. Plus this is the only cemetery where you see the use of egg cartons as flowers or crosses. Of course, I now know why that is, because there is this one lady who does that. She does it every spring and every fall, puts out new egg carton flowers for everybody's grave. She told me it makes no difference who is buried there, or when they were buried there; everybody deserves something on their grave. W.C.

William Christenberry
CHILD'S GRAVE WITH ROSEBUDS, HALE COUNTY, 1975

William Christenberry
GRAVE WITH EGG CARTON CROSS, HALE COUNTY, 1975

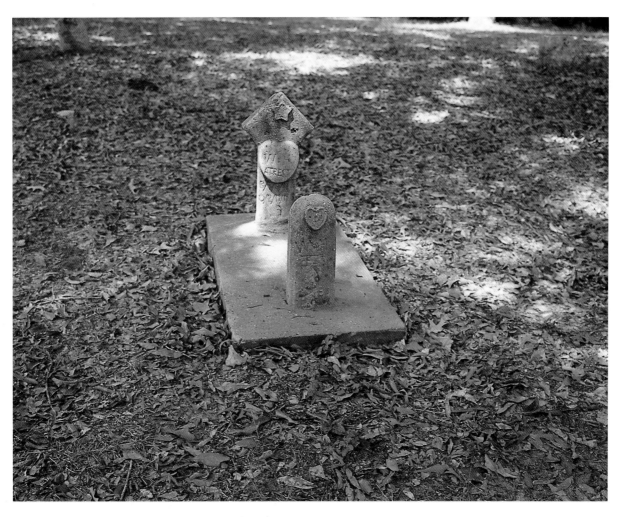

William Christenberry
GRAVE MARKER WITH STAR AND HEART, NEAR STEWART, 1988

Six or eight years ago, I was photographing Coleman's Cafe one day. And suddenly out of nowhere, like an apparition to my left was this black man, purple black, like you so often see in the deep South. Not light skinned, but beautiful purple black, and he was dressed all in white, white shirt, white shoes, white pants and a white hat. "Do you like that old building, son?" He didn't say, "Why do you like it?" He said, "Do you like it?" I said, "Yes, sir." "Then you ought to see my house." And more out of courtesy on my part and curiosity I said, "Well, where is it?" "Just down that road a little bit." "Let me finish up here and we'll go down and look at it." He said, "Fine." I was almost finished and I broke down the camera and he got in the car with me and showed me the way about a mile down the road. And I noticed his left arm from here down was missing, from right here down. And as we were driving he said, "Son, do you know where I can get any work?" And just the way he said it, I could have broken into tears easily, and I said, "No, sir, I don't."

"I lost this arm in a sawmill accident in nineteen forty something, and I have had a hard time getting any work since then." And I said, "I sure wish I could help you but I don't live here any more. My family's moved away." So by that time we had gotten down the road. He said, "There it is." So I pulled off on the shoulder of the road and there was this house, cinder block house, very small. You could see that he built it with one arm. You look at it closely and you see that the cinder blocks were not level. Flat roof, door painted pale yellow, cinder block painted washed-out white. So I expressed real interest in it, though it wasn't that terrific a piece of architecture. I know I hadn't noticed it before, but anyway I complimented him on it. "Let me show you the inside." "Okay." So we went around the back and he opened the back door and my heart sank because it didn't have any floor, just red earth. An old beat-up mattress over here, a little potbellied stove and a few rickety pieces of furniture. And I didn't know what to say.

Finally I set up the camera and he was very pleased that I photographed it. It was not too good, so when I got back here and saw the print I said, "Oh shoot, I've got to try that again, got to see that again, do it better."

The next time I went back, I pulled the car over on the side of the road, got out, and as I was walking towards the house another man to the right said, "Are you looking for Mr. so and so?" And I said, "Yes, sir." He said, "He died last February. He froze to death."

Every time I see that place, I do not know how to deal with that. He drank a lot so he probably had too much to drink and just went to sleep. I guess what I am trying to say is the effect of that man on that place is what I am interested in. It is there. I have not found how to do it yet. And I don't mean this in an egotistical way, but I don't often miss it. Maybe that place is just too close to me.  W.C.

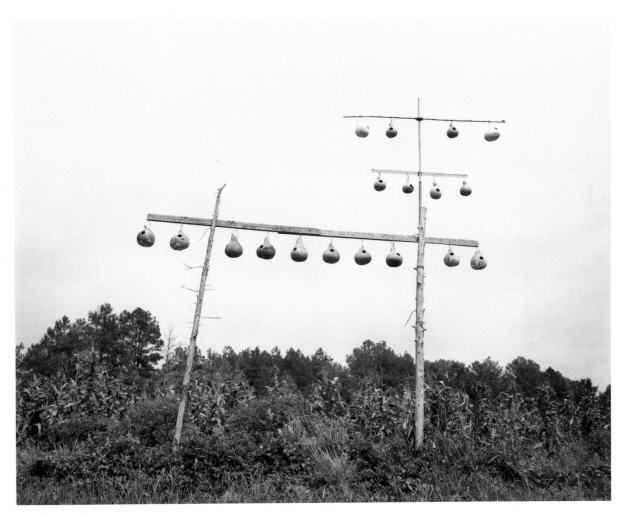

William Christenberry
GOURD TREE, NEAR FAYETTE, 1988

The Palmist Building is in my consciousness, has been most of my life as far back as I can remember. It was on the way in the forks of the road, literally between grandparents' houses— grandparents Smith and grandparents Christenberry—so we'd have to pass it. Especially when we lived in Tuscaloosa, we'd make that trek almost, if not every weekend to visit one or both of those families. It was a general store run by my great-uncle, Sydney Duncan, my father's mother's brother—she was a Duncan. And Uncle Sydney was a cantankerous man who drank a lot. Right after World War II, 1945-6, somewhere in there, my father drove a bread truck—Hardin's Sunbeam Bread—from Tuscaloosa down into Hale County, over to Marion in Perry County, and back. On Saturdays and holidays I would help him. I would go with him—that was when I was eight, nine, ten years old. And we'd always, of course, stop at Uncle Sydney's store and find out how many loaves of bread or cinnamon rolls he needed. My father would take the order and send me to the truck to get it. Then my next recollection was it becoming the Palmist Building. I don't remember when my uncle Sydney died or quit running it as a general store, but it was somewhere in the 1950s.

The first time I looked at it with a camera was 1961. I don't think it was functioning as a palmist building at any time I photographed it. The word I get from the landowner is that some gypsies came through that part of the county and they wanted to rent the space and he rented it to them. Things went all right for a while, and he went up there one day and they had skipped the country. Left owing a lot of rent, left the interior of the building in shambles, windows broken out. They left their old sign there, and the landowner just stuck it in the window to keep the rain out. Well, we know he stuck it in upside down, which made it more interesting than if it had been right side up, with the letters reversed. To me, I guess over the years it's become almost like an icon.

I am genuinely fascinated with the passage of time. I am fascinated by how things change, how one of these signs, for example—it was once in mint condition, an object put there to sell, advertise a product—takes on a wonderful character, an aesthetic quality through the effect of the elements and the passage of time. W.C.

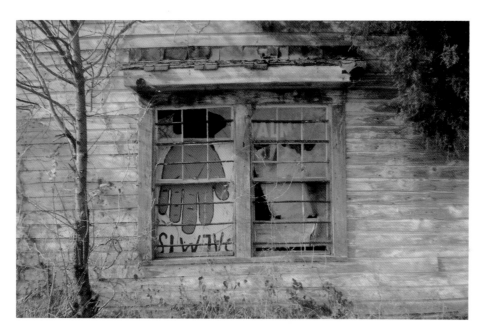

William Christenberry
SIDE OF PALMIST BUILDING, HAVANA JUNCTION, 1971

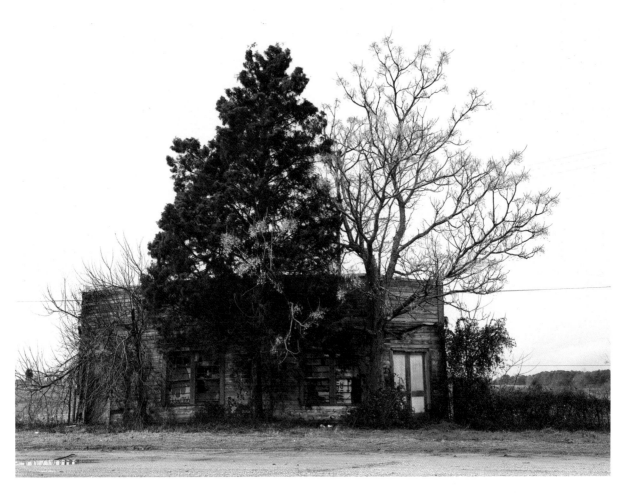

William Christenberry
PALMIST BUILDING (WINTER), HAVANA JUNCTION, 1981

I took my first sign ever off the Palmist Building in 1964. For some reason I found myself attracted to the oval shape of this purple Grapette sign which had bleached pretty much out to a kind of purple and red. It was rusted and about the size of a football.

I did not have my eye on the palmist sign at that time, but it couldn't have been more than two or three years later that I began to think seriously of the palmist sign itself. But I could not get to it, because burglar bars on the window were pretty substantial and there was always a lock on the door. I have done some pretty drastic things to get a good sign, but I wouldn't break into a building to get one. If I could have pulled it out through the window, that's another matter.

Several years later I asked my mother if she ever saw Mrs. A, and she said, "Yes, she is in the same church social that I am in." And I said, "Well, could you ask her next time you see her if they would be willing to part with the palmist sign?" My mother is a very shy, soft-spoken lady, and she brought this up next time she saw Mrs. A and Mrs. A said, "Oh no, we are not interested in getting rid of that sign." My mother's side of the story is that she said it in a way that hurt my mother's feelings to no end, and my mother's feelings are very easily hurt. So I said, "Don't worry about that, that's fine."

My uncle has a big farm near the A's and the Palmist Building. He knows them, and I said, "Would you ask for me?" "Sure." When he asked, his feelings weren't hurt, but he was also turned down.

The third time was after the 1978 *Aperture* article on my work. We were on our annual trip to Alabama, and I was determined to try myself to see if they would part with that sign. As I got down to their house, which is within two hundred yards of the Palmist Building, I literally chickened out, kept on driving. I got on down the road a bit, and I was talking to myself and said, "Listen, your mother has tried to get the sign, your uncle has tried. They have had no success. You either do it or forget it and shut up." So I turned around and came back up the road.

And I went into their driveway and pulled in near the back of the house. I got out of the car and I was literally inundated with bird dogs. Mr. A came to the door. And I said, "Good morning, I am William Christenberry, Jr." "I know who you are." I said, "You do?" "Hell yea. I know who you are, you're Christenberry." "Yes sir, how did you know that?" "By the shape of your nose. Come on in. We are just finishing breakfast. Come on in and have a cup of coffee with us." And I went in there and Mrs. A was finishing up her coffee and we chatted about the weather and her family and this and that. And she said to me, "William, we're very proud of you and what you are up to and your work. We read about you" and this and that.

Finally I said, "I don't know if you all are interested, but if you ever have a desire to part with that sign out there, I really would like to be considered for it." It was like I never asked the question. There was absolutely no response, like nothing was said, and that's terribly disconcerting. So I had to think fast. I altered the direction and changed the subject and went off on some other tangent.

In a few minutes I thought, I've got to try again. So I opened the *Aperture* quarterly to the page with the 1971 view of the palmist sign reproduced. I said, "I would be very very pleased to give you all a framed, actual photo, framed of this sign in this picture if you are interested in parting with the palmist sign." Absolute silence. And that made me a little angry. I don't know why, but it did. So I changed the subject again.

Finally—and I was there for the better part of forty-five minutes to an hour—finally, it got time to go and I said, "I enjoyed talking to you all." And he stood up, and he's a big man, and he said, "William. I can see now how important that sign is to you, so I'll tell you what we'll do." And I thought, now this is it. "We'll go up there to that old building and I'll take that sign out of the window and you can photograph it and I'll put it back." And I almost laughed, but I said, "Thank you, sir, but that is not quite what I had in mind." And I left.

The next year I had a show at the Montgomery Museum, and I made sure the A's had an invitation sent to them. They didn't come, and that was all right. Montgomery was about

eighty miles from there. But the next summer after that show I was there, photographing that sign in the window, as I did every year, and a pickup truck came up. And Mr. A said, "How are you, how are you doing?" We just exchanged greetings. I told him I was photographing again. And he said, "Oh William, I meant to tell you we were coming over to your exhibition. We really appreciated that invitation you sent us. We were going to come and we were going to tie that palmist sign on top of our car and bring it to you as a gift, but one of my wife's relatives got sick and we couldn't come." You know, what can you say? That was about the closest I ever came to getting it.

So the next year I was there and he came up and we were talking, and I decided, this time I am going to talk money—which is hard for me to do about a found object, because I prefer not to have to pay. It takes away something from finding it. We were chatting again, and I just said to him, "Mr. A, would you take twenty-five dollars for that sign right now?" He was actually walking away, and it stopped him. He turned and he said, "Well William," and you could see he was thinking pretty hard and fast. He said, "Can't do that; my wife's not here right now. We'll have to discuss that when she's here. Next time you are in this part of the country let me know and we'll talk about it." I said, "Mr. A, I am going to Memphis in the morning. I won't be back for another year." "OK, next time you are in this part of the country we'll talk about it."

The next summer, when I went back, the palmist sign was completely out of the window, gone. And then he came up—and my heart sank when I saw it boarded up—and after our usual greeting and talking about the weather, I said, "Well, I notice that the palmist sign is gone." One of my worst fears was that he was going to say that he'd sold it. He said, "Yea, we still have it, we have got it stored." He did not tell me where, and I didn't ask him. Just "We got it stored."

And then in 1983, April, we were working on the installation of the exhibition of my work at the Corcoran Gallery. And some other friends were given the job of designing the installation along with Walter Hopps. They called me one night and said, "Bill, we are fully aware of how much that palmist sign means to you. Would you object if we tried to get Mr. and Mrs. A to loan the sign to the museum?" I said, "No, I don't object to that. All I ask is that I want my family kept out of it because it is too easy to get feelings hurt." The country is so close sometimes, and everybody knows everybody else.

So my friends from Baltimore managed to contact the A's and called me back to say, "We are pleased to tell you the A's have consented to loan the sign to the Corcoran Gallery for your show. How are we going to get it up here, Bill?" I said, "All I know is that I am not going to ask my father to go down there and deal with this." The sign's bigger than it looks, about four by six feet, painted on masonite, a couple of bullet holes in it, lot of cobwebs, painted on the smooth side. Anyway, what the Corcoran Gallery did was, dealing with loan forms, just like any work of art, to have an art mover, coming up with some other work by way of Florida, circumvent its route to come through Havana Junction and rendezvous with Mr. A—and I speculate the sign was in the building but not in the window—and they loaded up the sign in the truck. The truck came to Washington. And we were working hard and fast on the installation in the galleries, and we knew where the sign was going to go. Two preparators came in wearing white gloves, two of them, carrying this piece of junk. "Where do you want this thing?" "Nail that son of a gun right to that wall right there." And we just nailed it up right through the holes, we didn't take off cobwebs, we didn't dust it, we didn't do anything, and it stayed there for three months and I thought, this has got to be it. They are going to call or write me, the A's are, and say, "William, because the sign's in Washington, just consider it yours." No way. The Corcoran Gallery paid three hundred dollars just to send it back. Three hundred up, three hundred back. Sent it back. And the last word I got through the Alabama grapevine is that they have said that since the sign has been in a major museum exhibition in Washington D.C., it now must be worth at least a million dollars. And I have sent word via my grapevine: "If you can get a million, take it." W.C.

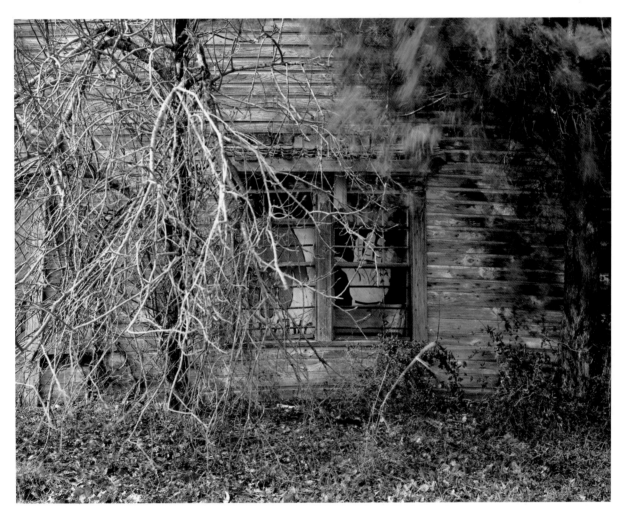

William Christenberry
WINDOWS OF PALMIST BUILDING (WINTER), HAVANA JUNCTION, 1981

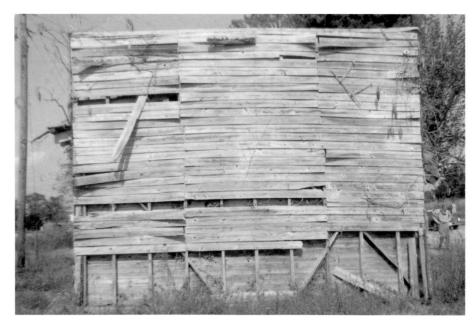

William Christenberry
PALMIST BUILDING, HAVANA JUNCTION, 1973

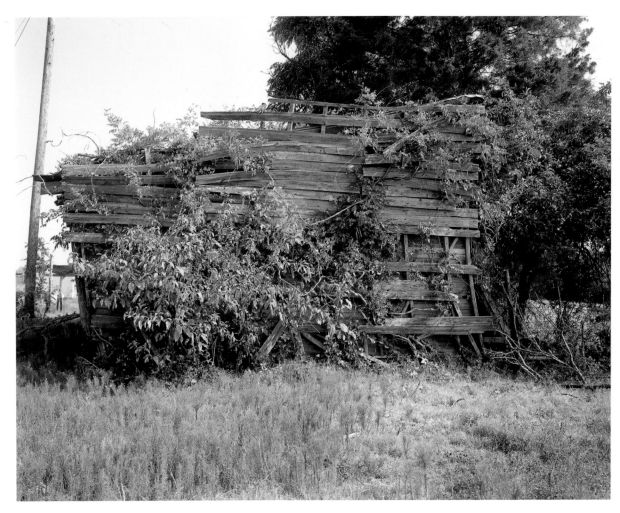

William Christenberry
SOUTH END OF PALMIST BUILDING, HAVANA JUNCTION, 1987

William Christenberry
SITE OF THE PALMIST BUILDING, HAVANA JUNCTION, 1988

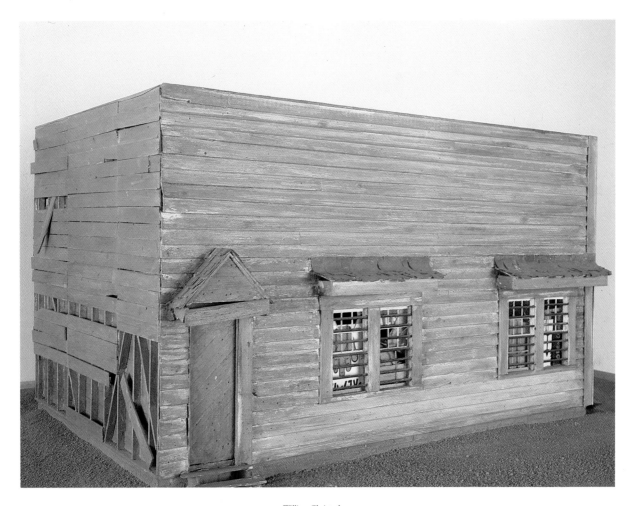

William Christenberry
PALMIST BUILDING, HAVANA JUNCTION, 1975
Mixed media sculpture
Photograph by Gregory R. Staley and William Christenberry

## THE FRIENDS OF PHOTOGRAPHY

The Friends of Photography, founded in 1967 in Carmel, California, is a not-for-profit membership organization housed in the Ansel Adams Center in San Francisco. The programs of The Friends in publications, exhibitions, education and awards to photographers are guided by a commitment to photography as a fine art and to the discussion of photographic ideas through critical inquiry. The publications of The Friends, along with admission to the Ansel Adams Center the primary benefit received by members of the organization, emphasize contemporary photography yet are also concerned with the criticism and history of the medium. They include the newsletter *re:view*, the periodic journal *Untitled* and major photographic monographs. Membership is open to everyone. To receive an informational membership brochure, write to Membership Director, The Friends of Photography, Ansel Adams Center, 250 Fourth Street, San Francisco, California 94103.

## AMON CARTER MUSEUM

The Amon Carter Museum was established through the generosity of Amon G. Carter, Sr., (1879-1955) to house his collection of paintings and sculpture by Frederic Remington and Charles M. Russell; to collect, preserve and exhibit the finest examples of American art; and to serve an educational role through exhibitions, publications and programs devoted to the study of American art and cultural history.

REG. U.S. PAT. OFF.